JEFF

KOONS

EASYFUN — ETHEREAL

Deutsche Guggenheim BERLIN

Published on the occasion of the exhibition
Easyfun-Ethereal
Organized by Lisa Dennison and Robert Rosenblum
with Craig Houser

Deutsche Guggenheim Berlin
October 27, 2000–January 14, 2001

ISBN: 0-89207-238-5

Guggenheim Museum Publications
1071 Fifth Avenue
New York, New York 10128

Deutsche Guggenheim Berlin
Unter den Linden 13–15
10117 Berlin

Distributed by
Harry N. Abrams Inc.
100 Fifth Avenue
New York, New York 10011

Book design: Pandiscio Co., Senior Designer Takaya Goto

Printed in Germany by Cantz

The Solomon R. Guggenheim Foundation

Contents

Foreword

DR. ROLF-E. BREUER

Spokesman of the Board of Managing Directors of Deutsche Bank AG

Easyfun-Ethereal—seven new paintings by Jeff Koons. To be seen for the first time at Deutsche Guggenheim Berlin. When the curators of the Guggenheim Museum, Lisa Dennison and Robert Rosenblum, suggested our cooperation with the artist at the beginning of the year, the decision was not difficult. We were delighted to invite this important artist to receive the fifth commission for Deutsche Guggenheim Berlin. Internationally, he is one of the most widely known contemporary artists, while in Germany his artworks have repeatedly been met with great interest. The Staatsgalerie in Stuttgart presented a comprehensive retrospective in 1993, and Koons's pioneering sculptures have been created for exhibitions and squares throughout Germany, including *Kiepenkerl* in Münster in 1987; the floral *Puppy*, which was originally viewed at Schloss Arolsen in 1992 and became part of the permanent collection of the Guggenheim Museum Bilbao in 1997; and most recently, *Balloon Flower* at the Marlene-Dietrich-Platz in Berlin. The artist also lived in Munich during the early 1990s. Yet, his latest paintings have not been seen in German museums.

Easyfun-Ethereal connects formally with Koons's advertising themes from the mid-1980s. The new paintings of the Berlin series emphasize the collage technique. Designed at the computer, surprising conglomerations present complex layers of meaning. The everyday themes, however—and this is characteristic of Koons—contrast with the medium of their presentation. Created in an atelier, traditional oil painting rendered in photorealistic perfection conserves and refines a consumer aesthetic while translating it into a work of art of luxurious glamour: Koons's paintings are seductive, a visual land of milk and honey. Whether you succumb to the temptations or not, if you prefer pleasure or asceticism, the immediate relevancy as well as the challenge of Jeff Koons's paintings lie in their parallelism to the world of advertising and media.

Preface and Acknowledgments

...

THOMAS KRENS

Director, The Solomon R. Guggenheim Foundation

From the late 1970s to the present, Jeff Koons has created an exceptional body of artwork that reflects deeply upon the complex concerns of late-capitalist culture. As we unveil Koons's first works of the twenty-first century, the seven newly commissioned paintings for the Deutsche Guggenheim Berlin, the artist is featured in a number of important international exhibitions, leaving no doubt that he is one of the most radical, significant, and influential artists of his generation. The imagery in his almost deliriously optimistic new works has been drawn from personal photographs and the familiar world of glossy magazines, brochures, and advertisements, which—through shifts of context, scale, and material—are reshuffled into kaleidoscopic panoplies of childhood and adult indulgences and fantasies. Keeping his finger on the pulse of contemporary culture, the artist has created a new brand of Pop painting in order to realize his stated ambition "to communicate with the masses."

Each of the institutions that form the network of Guggenheim Museums is fortunate to have developed a unique and significant relationship with Koons. The Solomon R. Guggenheim Museum in New York will mount a major retrospective exhibition that will provide audiences with an in-depth perspective of the artist's acclaimed career. Koons's flowering topiary sculpture, the internationally famous *Puppy*, was purchased for the permanent collection of the Guggenheim Museum Bilbao in 1997 and stands as a sentinel at its gates, where it has come to serve as the emblem of the museum and the city. And presently, the Deutsche Guggenheim Berlin displays the commissioned *Easyfun-Ethereal* series. Created at the turn of this century, at a time when we pause to reflect upon the last one hundred years, these paintings not only address contemporary culture and Pop art but also refer to other key artistic movements from throughout the twentieth century, most notably Surrealism and Abstract Expressionism. Fusing these artistic styles together in his depictions of popular imagery, Koons creates a hybrid of fun and fantasy that engages both past and present.

Such a project could not have been realized without the incredible efforts of individuals from Deutsche Bank and the Solomon R. Guggenheim Museum. The Deutsche Guggenheim Berlin is a core institution of the new German capital, having contributed so much to Berlin's cultural vibrancy since opening in 1997. First, I want to thank Dr. Rolf-E. Breuer, Spokesman of the Board of Managing Directors of Deutsche Bank, who

has remained steadfast in his commitment to supporting our collaboration. My gratitude also goes to Dr. Ariane Grigoteit and Friedhelm Hütte, Deutsche Bank Collection Curators, for their enthusiasm and dedication to this particular commission. In addition, I would like to recognize Svenja Simon, Deutsche Guggenheim Berlin Gallery Manager, who, along with Sara Bernshausen, skillfully managed the organizational aspects of our project. Britta Färber of the Deutsche Bank Arts Group also provided assistance throughout the planning process. Elisabeth Bushardt, a conservator for Deutsche Bank, advised on the packing and shipping of the paintings to Berlin, and Markus Weisbeck from Surface Gesellschaft für Gestaltung was responsible for the exhibition-related materials.

From the Solomon R. Guggenheim Museum, I thank Lisa Dennison, Deputy Director and Chief Curator, Robert Rosenblum, Stephen and Nan Swid Curator of Twentieth-Century Art, who served as curators for the project, and Craig Houser, Assistant Curator, who oversaw all aspects of the exhibition and publication. Their tremendous knowledge and experience and close collaboration with the artist proved to be invaluable to the realization of this exhibition. I would also like to acknowledge Jane Debevoise, Deputy Director for Program Administration; Ben Hartley, Director of Corporate Development; Max Hollein, Chief of Staff and Manager of European Relations; Nic Iljine, European Representative; Marion Kahan, Exhibition Program Manager; Maria Pallante, Associate General Counsel; Paul Pincus, Director of International Planning and Operations; and Gail Scovell, General Counsel, who on an ongoing basis contribute to the realization of exhibition programming for the Deutsche Guggenheim Berlin. The intricacies involved in coordinating this exhibition were superbly managed by Meryl Cohen, Head Registrar; Alexis Katz, Architectural CAD Coordinator; Carol Stringari, Senior Conservator; and Emily Waters, Chief Graphic Designer.

For their contributions to the publication, I thank David Sylvester and Robert Rosenblum, whose interview and essay, respectively, provide throughtful insight into the artist's new work, as well as his career. Richard Pandiscio and Takaya Goto from Pandiscio Co. designed a most exquisite book. Photographs documenting the artist's working process for the commission, in addition to images from the artist's studio, appear throughout the catalogue as a result of the exceptional efforts of David M. Heald, Director of Photographic Services and Chief Photographer. Ellen Labenski, Assistant Photographer, also contributed her talents to the book.

The museum's gifted Publications Department skillfully handles the production of books for the Deutsche Guggenheim Berlin. I would like to thank Elizabeth Levy, Managing Editor/Manager of Foreign Editions, who expertly oversees the publication of each title, and Elizabeth Franzen, Manager of Editorial Services, who deftly manages the preparation of texts in both English and German. I also thank Cindy Williamson, Assistant Production Manager, for her help with all aspects of production for this catalogue; Jennifer Knox White, who carefully edited the original English texts; Rachel Shuman, Assistant Editor, and Edward Weisberger, Editor, for their editorial expertise; and Bernhard Geyer, Jürgen Riehle, and Marga Taylor for sensitively translating and editing the texts for the German edition. Curatorial interns Tatiana Gonzalez and Aimar Arriola compiled entries for the exhibition history and bibliography.

On behalf of the artist and the Guggenheim Museum, I thank Ileana Sonnabend and Antonio Homem, Director, Sonnabend Gallery, New York, for their help with this commission. Jason Ysenburg, Assistant Director, Sonnabend Gallery, also contributed to the project. From the artist's staff, I would especially like to recognize the tremendous efforts of Gary McCraw and Justine Wheeler, as well as the numerous studio assistants who made the project possible.

Last, I offer my profound thanks to Jeff Koons. His upbeat spirit has guided and inspired us all throughout this process, and this new body of work is yet another brilliant chapter of his most remarkable career.

Jeff Koons Interviewed

...

DAVID SYLVESTER

New York City, February 6, 2000

DS: When you were first working on the *Celebration* series [1994–present], there was sometimes quite a team of assistants. How many assistants did you have on your recent series of paintings, which are a part of *Easyfun* [1999]?

JK: I had one person on the color table at all times, mixing colors as we went along. And then I had three people painting, and at times, with myself, four, and even another assistant stepping in.

DS: With the *Celebration* paintings, you'd often explain where you were with a piece by telling me what you were telling the assistants about the changes that you wanted. And I was always struck by the precision of it, by the way you were able to define exactly what you wanted and exactly what you did not want and why.

JK: You know, art, to me, is communication. I try to communicate to the assistants, and of course the assistants who are with me now have worked with me over a long period of time, and they know what I'm looking for. To communicate ideas, verbally or visually, you have to repeat. So I'm not afraid to continue to let everybody know what I'm looking for. I hope that the work, when it presents itself, continues to state what its ideas are.

DS: With these three new paintings [from the *Easyfun* series], were all the ideas ready before you made any of them?

JK: There was an image that I saw, which was of a cutout. Like if you go to an amusement park or a fair, there might be a board that's painted—maybe it's an astronaut—and you put your head through a cutout in the plywood, and then you're the astronaut. Anyway, this image I saw was of a workhorse, and I really liked it. So I kept it for a long time, because I love two-dimensional sculpture, and I knew that I wanted to make a painting with this idea of a cutout. This was the first of the three, and I called it *Cut-Out*. Then, I guess, the second one that I started to develop was *Hair*, and the last one was *Loopy*. They all have their own texture, and they're kind of dealing with different aspects of abstraction.

DS: Did you find the cutout of the horse in a photograph or in a Disney image, say, or on a cereal packet or anything?

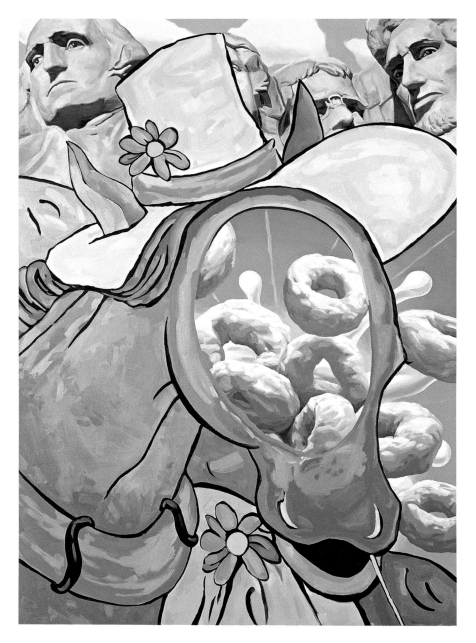

Figure 1. *Cut-Out*, from *Easyfun* series, 1999, oil on canvas, 2 x 1.1 m. Collection of Davide Halevin, Italy

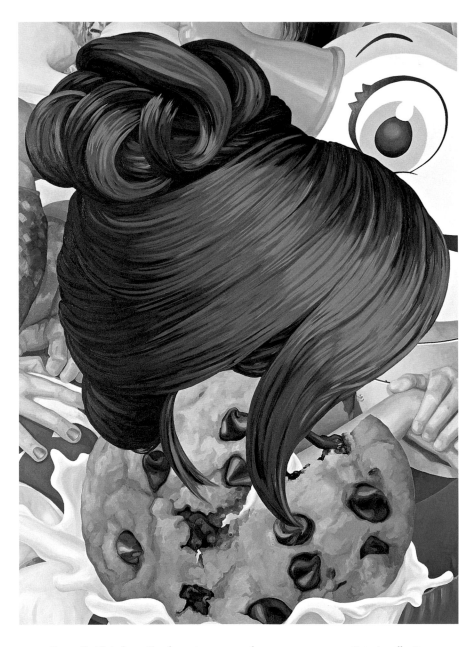

Figure 2. *Hair*, from *Easyfun* series, 1999, oil on canvas, 2 x 1.1 m. Private collection

JK: The idea came from a photograph in a newspaper. The image is slightly manipulated. I wanted to pick up aspects of the workhorse, so I put in these little iron things and threw in a flower in the hat—things like that. My painting is really, for me, about my background. I was trying to show that I come from a provincial background. Eventually, over a period of time, the provincial always wins. When I've made other bodies of work in the past, or images, I've worked with things that are sometimes labeled as kitsch; but I've never had an interest in kitsch per se. I always try to give the viewers self-confidence, a foundation within themselves. For me, my work is about the viewer more than anything else. My work, I think, is a support system for people to feel good about themselves and to have confidence in themselves—to enjoy life, to have their life be as enriching as possible, to make them feel secure. I mean, what I really try to do is to give people a confidence in their own past history, whatever that may be, so that they can have enough self-respect to move on, to achieve whatever they want. There's Mount Rushmore in the back of *Cut-Out*, that's kind of saying, "If you want to grow up to be President . . ." And the cereal exploding with milk behind: that's just optimism. You can put your head through a cutout and for the moment become whatever you want to be. Mount Rushmore in the sky, I painted the sky there. I looked at images from *Winnie the Pooh* and different colorful images like that, again, to give a very optimistic feel to it.

DS: It has great elation. And it's nice that instead of a head coming through the hole, there are a lot of Cheerios.

JK: The texture of them is such that sometimes you look and they could even be bagels. I wanted this painting in particular to have this texture, like a cutout. A cutout would not have a perfectly defined surface. It's something that would be done rapidly, because it's just used at an amusement park or a fairground. Nobody's going to labor on it too long. So I don't know if they're Cheerios; they could be bagels. I mean, the texture gives it just this little bit of abstraction.

DS: And in *Hair*, where did the hair come from?

JK: The hair came from an ad in a magazine—a coupon-type ad. It was originally of a blonde. Trying to create more of an image of Everywoman,

I changed it from blonde into this kind of brownish color with blonde and red highlights and brunette aspects. The cookies came from, again, those coupon-type advertisements in the newspapers. The background came from a box for an inflatable toy, that sort of image where people are in a pool, with young children playing with an inflatable toy. For me, that painting's about sexuality. When I look at it, I always have to go to my mouth and feel like I'm pulling a hair out of it.

DS: The chocolate-chip cookies are a very erotic image or an alternative to a very erotic image.

JK: I've always loved the *Venus of Willendorf*, and I think *Hair* has that aspect of fullness.

DS: And the whipped cream and cherry in *Loopy*?

JK: *Loopy* is a collage of a rabbit along with whipped cream and a cherry. I also added a face made out of cereal. But it was more like a spatial ab-

straction that I got involved with. Then I have these whiteouts that are kind of John Baldessari–type circles. But, because of their placement within the collage, some are overlapped by the cereal and some are right on top of the image.

DS: Did the cereal remind you of the basketballs in the *Equilibrium* series [1985]?

JK: Yes. I mean, as far as it's floating in space there. And even the whiteouts reminded me of them too. But I wanted to make this painting a very aggressive, visual painting. I love Pop art, and I really want to play with aspects of Pop. So much of the world is advertising, and because of that, individuals feel that they have to present themselves as a package. The work gives them a sense that they really feel they are packaged, like this cherry.

Childhood's important to me, and it's when I first came into contact with art. This happened when I was around four or five. One of the greatest pleasures I remember is looking at a cereal box. It's a kind of sexual

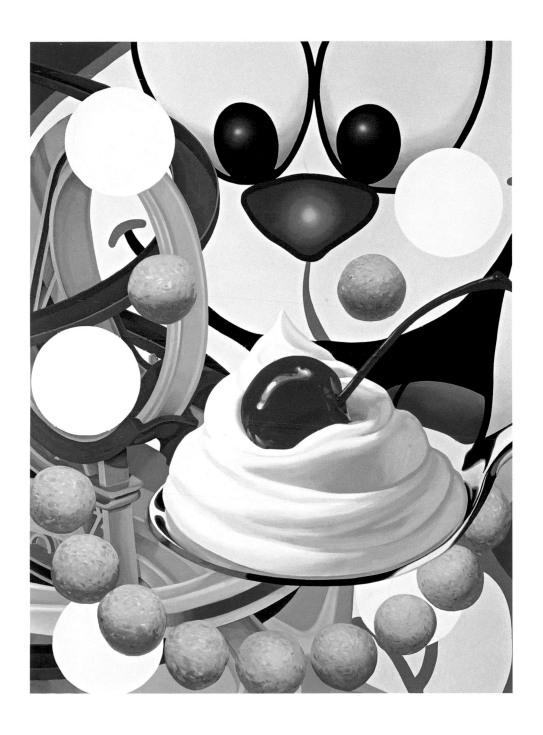

Figure 3. *Loopy,* from *Easyfun* series, 1999
Oil on canvas
2 x 1.1 m. Collection of Angela
and Massimo Lauro

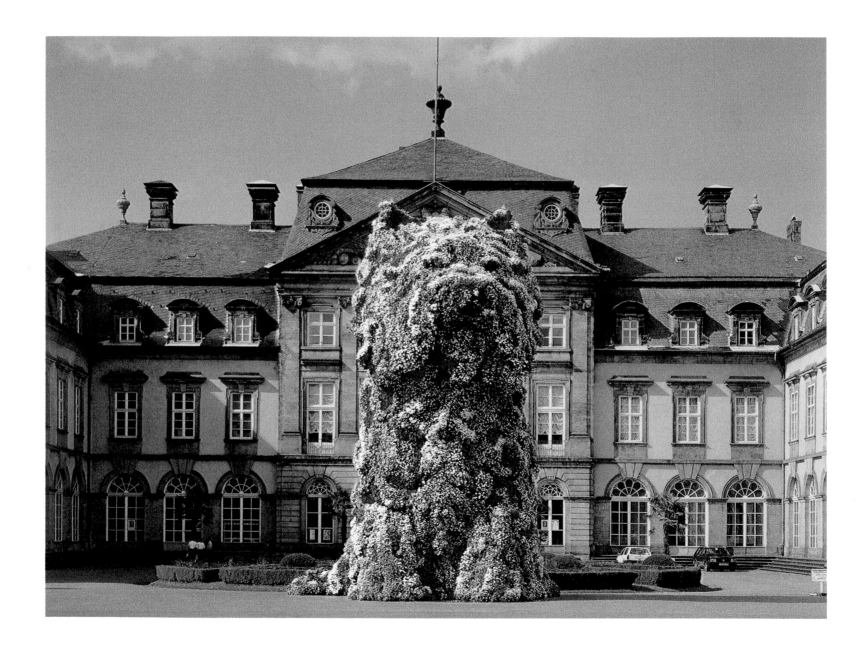

Figure 4. *Puppy*, 1992, live flowers, earth, wood, steel, 12 x 5 x 6.5 m. Installation view

experience at that age because of the milk. You've been weaned off your mother, and you're eating cereal with milk, and visually you can't get tired of the box. I mean, you sit there, and you look at the front, and you look at the back. Then maybe the next day you pull out that box again, and you're just still amazed by it; you never tire of the amazement. You know, all of life is like that or can be like that. It's just about being able to find amazement in things. I think it's easy for people to feel connected to that situation of not tiring of looking at something over and over again, and not feeling any sense of boredom, but feeling interest. Life is amazing, and visual experience is amazing.

DS: It's very interesting how certain artists of our time have dealt with childhood in some ways more precisely than it's ever been done before. Magritte constantly reminds us of various childhood activities and games. Johns's work seems to me to be about a lonely childhood, about a child alone in the schoolroom. It seems to be about a very sad childhood. Your work seems to be about happiness and excitement in childhood. Did you in reality have a happy childhood?

JK: I think other people could have had a much more painful childhood than myself. I have fond memories of my childhood, and I think of those years as supporting. I know that I deal with that experience within my work.

I have a son, and art is such a wonderful experience to be able to watch occur in young children. My work has continued to go in this direction. It's about being able to create a work that helps liberate people from judgment. First of all, the art has to make them feel that it isn't making any judgment on them. Then, it has to free them to have the confidence to understand that judgment being placed on them in life is irrelevant; there's no place for it. So sometimes when I'm with my son and he's making a drawing, he'll pick up a dark purple marker to put in an area. And in my own mind I'll think, "If only he would use the orange, it would be so much nicer." But then he'll use that dark purple, and it's beautiful. Just because of this confidence and this sense of self, it can't be wrong. I try to give my son this self-confidence that he can't do anything wrong. I mean, if he's making a mark and puts something down and then tears it up and says, "That's not right," I'll say, "Well, why is it not right?" "Well,

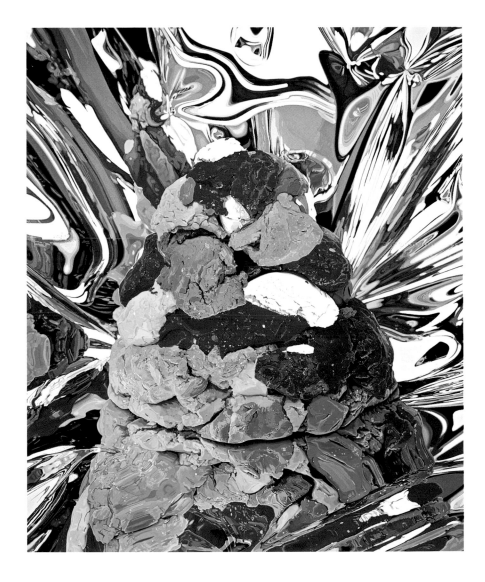

Figure 5. *Play-Doh*, from *Celebration* series, 1995–present, oil on canvas, 3.4 x 2.8 m. Private collection

it's not right." "Well, you know, you're in control of making this. And if you take your arm and you do this, it's right."

So when I made my sculpture *Play-Doh* [1994–present], I was very consciously trying to make a work that's about no judgment. You know, the viewer can't judge it, and it can't be wrong. It's just this mound of Play-Doh. You know, the intentions were good in doing it. I tried to give myself all the freedom of piling it up.

DS: The preoccupation with experiences of childhood goes back a long way in your work. But do you think it's been altered by closely watching, as you have, your son playing? Are you conscious of how watching Ludwig play has affected your work?

JK: Absolutely. The education that I've gotten back from him is like tenfold. I mean, it's like an avalanche or a tidal wave. I've always been aware of art's discriminative powers, and I've always been really opposed to it. It's just helped me simplify my method of being able to deal with that, and to try to go against this discriminative power of art.

DS: I was very excited to see the *Easyfun* series we've been talking about because over quite a long period I've been seeing the *Celebration* paintings and loving them, and the *Celebration* sculptures even more. They've seemed to me to get better and better; in your continuing to work on them, there was nothing neurotic or obsessional about it, but you were actually making those paintings and sculptures better. It's been gratifying to see how, in these three new paintings, you've gone off on another tack. But what's going to happen, or what has been happening, to the *Celebration* works? I know you have had difficulties with the sculptures.

JK: What happened with *Celebration* is that originally it wasn't going to be a huge body of work. And for a variety of reasons, it developed into a larger body of work that was going to be exhibited at the Guggenheim in New York. So the project demanded more work and time than a normal gallery exhibition. But we ran into financial problems. It's not that I didn't do my work, or that I was being too obsessive about my work. At the end of the day, the problem came down to increased costs for fabrication that were beyond our control. David, I believe in art morally. When I make an artwork, I try to use craft as a way, hopefully, to give the

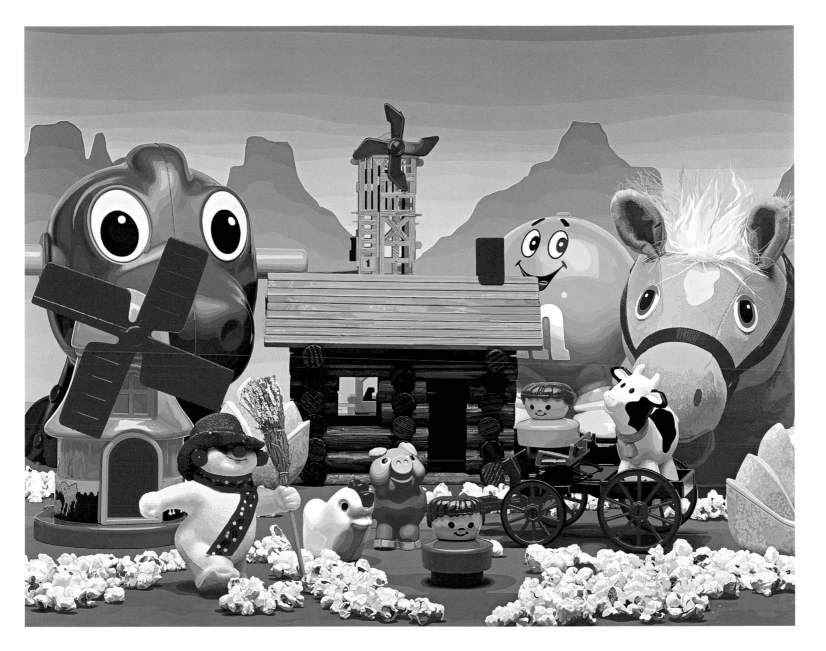

Figure 6. *Shelter*, from *Celebration* series, 1996–97, oil on canvas, 3 x 3.8 m. Collection of Rachel and Jean-Pierre Lehmann

Figure 7. *Split-Rocker (Orange/Red)*, from *Easyfun* series, 1999, polychromed aluminum, 34.3 x 36.8 x 33 cm. Collection of B. Z. + Michael Schwartz, New York

viewer a sense of trust. I never want anybody to look at a painting, or to look at a sculpture, and to lose trust in it somewhere. Now, let's say it's a sculpture. Typically, the attitude is that you pay attention to the front of a sculpture, and at the back, where somebody doesn't see it; well, you can get away with not doing so much. I would never want anybody to walk around and look at the back and feel that something was missing, that less support was there.

It's a shame the work was not able to be realized for the show that was originally planned. But I really love the *Celebration* work, and I'm happy that the pieces have started coming out, so that the public is able to see them.

DS: Peter Schjeldahl has said that if there was an artist today whose work should be in every public place, it was you.

JK: That's kind.

DS: I'd like to see that happening with the *Celebration* sculptures.

JK: I enjoy seeing them come into this world, and I look forward to seeing the public respond to them. Because, as I was saying earlier, it's really what they carry away about themselves that is the work. One version of my *Puppy* [1992] is in front of the Guggenheim Museum in Bilbao. Its location is the high end of where public sculpture may be. Another *Puppy* is going to be at Rockefeller Center later this year. This is an incredible location. At one point, there was even talk of it ending up in an entertainment complex in Arizona with a sporting arena for a hockey team and huge theaters for films and shops. When I first realized that this was going to be the home of *Puppy*, I thought, "Mmm . . . I don't know." Maybe I always thought a city would get it for its park or something. Even though *Puppy* is not going to end up in the entertainment complex, I really just came to the realization that every place that public sculpture goes is really similar today to a mall, or it's a commercial environment.

My own art is about aspects of entertainment. I believe that one of the increased interests in art today is not just economics but that the form of

entertainment that art's providing is more passive than other competing things. The passivity of television is something that art is kind of fulfilling. Because even though we speak about the Internet as a kind of public entertainment, the Internet is not passive. There's a lot of layering. To get the information you want, or if you want to communicate, you have to keep going; you have to keep doing. Whereas art is a more passive type of experience physically. Mentally, it's maybe not passive, but physically it is.

DS: Your work often makes me think of the Baroque, and you've said the same thing yourself.

JK: I have always loved the Baroque, because I love the negotiations in the Baroque: the symmetrical against the asymmetrical, the aspect of eternity through spiritual life or biologically through procreation.

DS: The Baroque does give one confidence and comfort in existence, does it not?

JK: I think so. But the Baroque for me has always placed the viewers in a state open to intervention. It gives them enough confidence and security to do that.

DS: When we were in the studio earlier, there were the plasters of some of the *Celebration* sculptures, and I felt I was walking from one Bernini fountain to another. Also, you showed me the *Play-Doh* painting [1995–present], which you've started working on again, and that is an utterly baroque work. The weight of those volumes yet at the same time the éclat, the explosive vitality, this combination of solidity and upward movement is very baroque.

JK: With *Play-Doh* and the other *Celebration* paintings, I started with photographs that I shot from little setups, almost like a form of still life, and then from that I made a projection onto the canvas and put the basic proportions there, and whatever else I could still pick up from the photograph. Then the paintings went through this process of being stylized into a kind of superrealism through a kind of paint-by-numbers method. It's not that we were laying numbers down there, but specific shapes, so that

Figure 8. *Split-Rocker*, 2000, stainless steel, soil, geotextile fabric, internal irrigation system, live flowering plants, 12.2 x 11.8 x 10.8 m. Installation view. Private collection

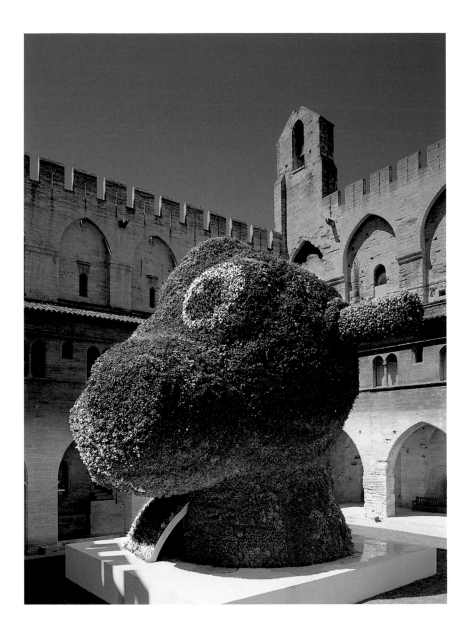

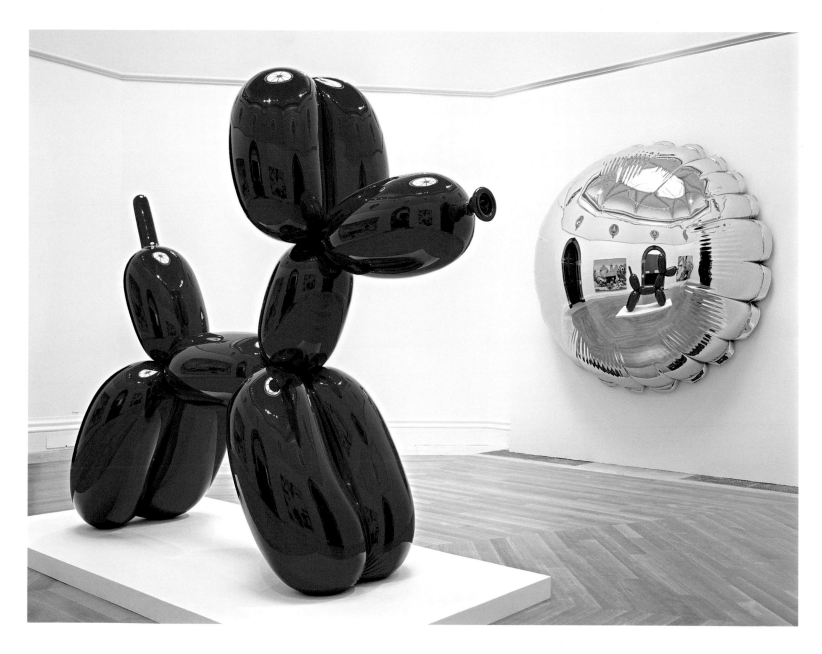

Figure 9. *Balloon Dog* (foreground), from *Celebration* series, 1994–2000, stainless steel with transparent color coating, 3.2 x 3.8 x 1.2 m.
Installation view. Private collection

there was no blending, so that it was all hard edge against hard edge. But you have to continue to be able to create ways to make breakdowns—to have something go from light to dark—so that it doesn't become Op Art in style, and so that it works in kind of a highly superrealistic way. I mean, that's my goal. But they still have a coloring-book type quality. They're bright, and they're very Pop. They maintain an innocence about them.

DS: Going to sculpture, tell me about that recent small piece called *Split-Rocker* [2000].

JK: It comes from a polyethylene rocking horse. I like the title, *Split-Rocker*, because you think of maybe a rock star having a split personality or a person with a schizophrenic quality. But it's really an innocent image that at the same time is menacing. My son happened to have this rocking horse, and when I was working on *Shelter* [1996–97], the painting, I thought I needed something for scale in the background, so I used that. Then I remembered another rocker that I had found, which was a dinosaur. So I would lay in bed, and I'd think it would be great just to cut

them down the center and put them together, and then put the bar back through the handle. So I finally did it [in *Split-Rocker*, a sculpture from the *Easyfun* series]. Because of the nature of their forms, the horse has an eye looking out to the right and the dinosaur's eye is looking straight forward. So there are references to Picasso. I love two-dimensional sculpture, such as Picasso's wooden pieces and Roy Lichtenstein's sculpture. But for *Split-Rocker*, what I was really interested in was the split, where there actually isn't any form, that interface where the overlap occurs. The space between the two is really what I was interested in. Though the piece has a sweetness, it also has a Minotaur-type quality to it, or a Frankenstein-type quality.

DS: So along with the allusion to the rocking horse, and along with a certain comic quality, it has at the same time a menace, even a horror.

JK: I think that's in a lot of my work, David, even though pieces sometimes can seem so optimistic. Like *Balloon Dog*. It's a very optimistic piece; it's like a balloon that a clown would maybe twist for you at a birth-

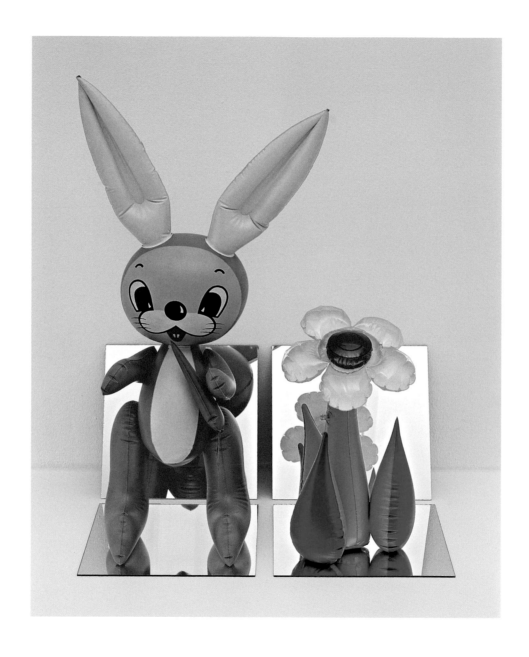

Figure 10. *Inflatable Flower and Bunny*, from *The Pre-New* series, 1979, plastic, mirrors, Plexiglas, 63.5 x 40.6 x 45.7 cm. Private collection

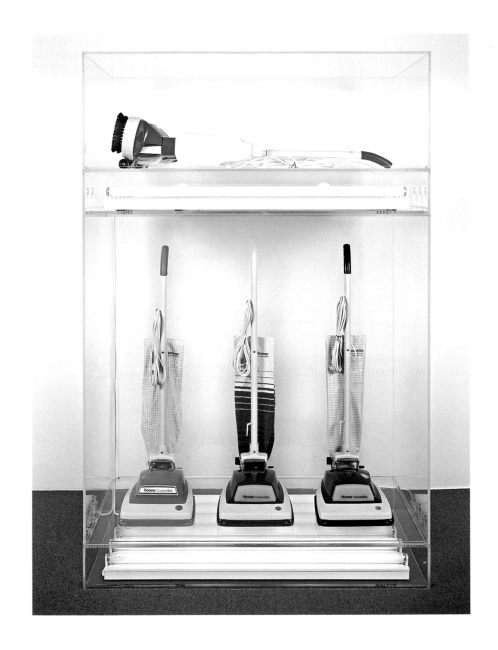

Figure 11. *New Hoover Convertibles, Green, Red, Brown, New Hoover Deluxe Shampoo Polishers Yellow, Brown Doubledecker*, from *The New* series, 1981–87, three vacuum cleaners, two shampoo polishers, Plexiglas, fluorescent lights, 2.1 m x 1.4 m x 71.1 cm. Private collection

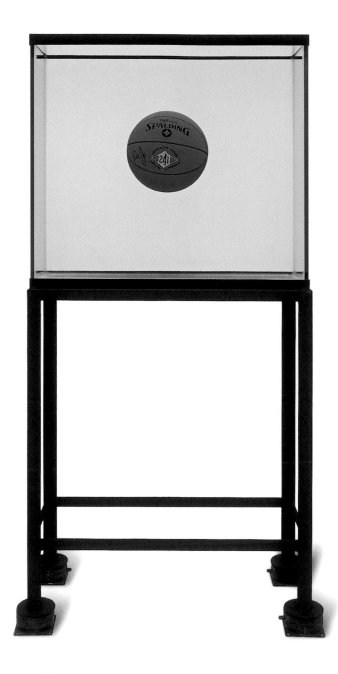

Figure 12. *One Ball Total Equilibrium Tank*, from *Equilibrium* series, 1985, glass, steel, sodium chloride reagent, distilled water and basketball, edition of two, 160 x 78.1 x 33.7 cm

day party. But at the same time it's a Trojan horse. There are other things here that are inside: maybe the sexuality of the piece.

Or even like the sculpture of *Play-Doh*. It has this external aspect about it, but it's actually a sculpture with twenty-five separate sections that lay on top of each other. The inside of the sculpture, to me, is as important as the outside, because it's like the subconscious of the piece, the internal reality of the piece.

JK: I never consciously sit down and try to create a work that is optimistic and that at the same time has a dark side. I just follow my intuition. If I am feeling a little down or something, my images probably present themselves as happier or more upbeat. But I'm not doing it on a conscious level. I think that I'm doing it on a truthful level. I hope that my work has the truthfulness of Disney. I mean, in Disney you have complete optimism, but at the same time you have the Wicked Witch with the apple. I don't tend to be pulled toward the idea of making a menacing work, but if I ever was pulled to that, I'm sure that it would also have this other aspect connected.

With my early work, I was always making an effort to remove the sexuality. Like with my first inflatables—say, the rabbit and the flower [*Inflatable Flower and Bunny*, 1979]—I felt that I just wanted to keep removing my own sexuality, this more subjective aspect of my work. That's where I got pulled to things like vacuum cleaners and basketballs, these kind of ready-made objects. But sexuality is such a tool, and I try to use it in an objective way. A communal sexuality, not just mine.

DS: The vacuum cleaners are very sexual.

JK: They have kind of a male-female aspect. They're anthropomorphic.

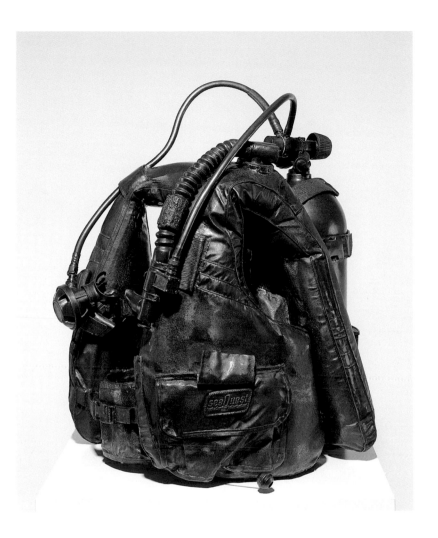

Figure 13. *Aqualung*, from *Equilibrium* series, 1985, bronze, edition of three, 68.6 x 44.5 x 44.5 cm

They're like lungs, breathing machines. I went on and did the *Equilibrium* series because I wanted to do work that, again, was distanced more from my sexuality. From a consumerist standpoint, I wanted the work to be more related to male consumerism, whereas vacuum cleaners are more geared toward female consumers. So I did the *Equilibrium* pieces, which are all in browns and oranges and have a sense of the weight of bronze. The basketball hovering in the tank [*One Ball Total Equilibrium Tank* (1985)] is like a fetus in the womb, it's an ultimate state of being.

After doing my *Equilibrium* show, the next work I did was the *Luxury and Degradation* series [1986]. It was the first time I'd worked with stainless steel. I liked its proletarian quality: pots and pans are made out of it. I was walking down the street and saw this ceramic train filled with Jim Beam and I thought: "This would be a great readymade." So I cast it and went back to the company and had it filled with bourbon and sealed with the tax stamp [*Jim Beam–J. B. Turner Train*]. Because, for me, the bourbon was the soul and the tax-stamp seal was like the interface to the soul. It was about creating something that you'd desire. I wanted to create work that people would be attracted to. There was a wide range of works: I made casts

of a pail with liquid measurement [*Pail*], a little bar tool kit with swizzle sticks and stuff [*Travel Bar*], and a Baccarat crystal set [*Baccarat Crystal Set*]. In the 1960s, people would travel with their liquor with them. The higher you went economically, the more luxurious the objects they used to carry it became. The *Jim Beam–J. B. Turner Train* was like the middle class. I also found all these liquor ads that were targeted to drinking audiences at different income levels: at like a $10,000 income level, which is the lowest level, targeting people for beer and cheap liquor, up to the highest, at $45,000 and up, targeting people for Frangelico. So I had these images made into paintings. It's very clear in these liquor advertisements that the more money you make, the more abstraction that's laid on you. In this series, I was telling people not to give up their economic power—that this pursuit of luxury was a form of degradation and not to get debased by it but to maintain their economic power. I was really telling people to try to protect themselves from debasement.

After *Luxury and Degradation*, Ileana Sonnabend asked a group of artists—there were four of us—to make an exhibition at her gallery, so I did a body of work called *Statuary* [1986], and to me, it was a panoramic view of

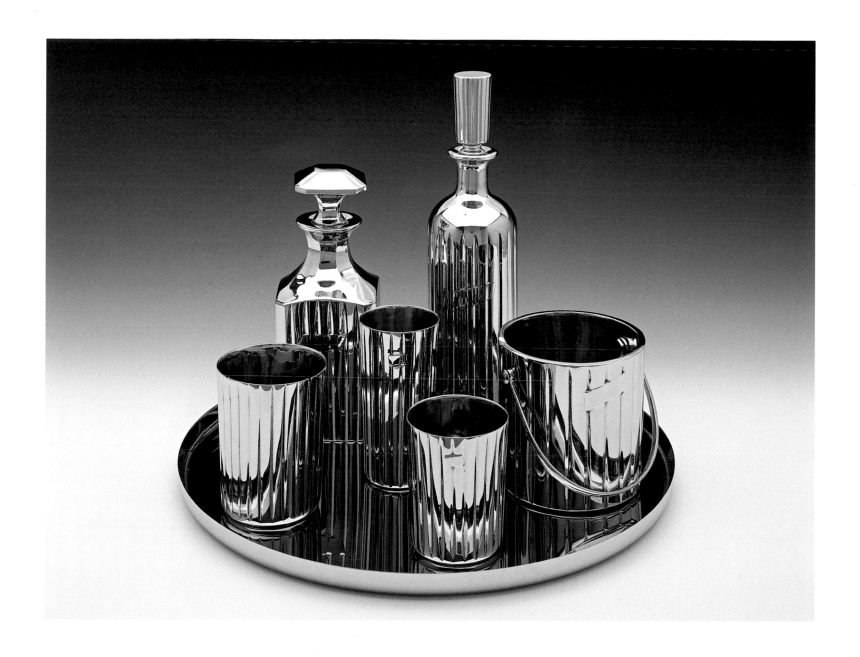

Figure 14. *Baccarat Crystal Set*, from *Luxury and Degradation* series, 1986, stainless steel, edition of three, 31.8 x 41 x 41 cm

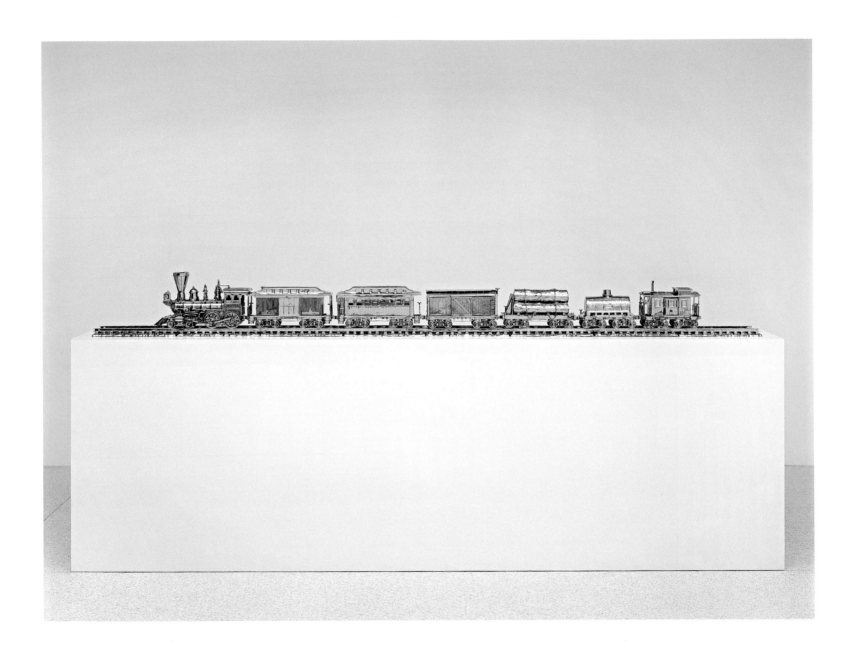

Figure 15. *Jim Beam–J. B. Turner Train*, from *Luxury and Degradation* series, 1986, stainless steel, edition of three, 28 cm x 2.9 m x 16.5 cm

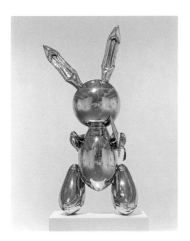

Figure 16. *Rabbit*, from *Statuary* series, 1986, stainless steel, edition of three, 100 x 48.3 x 30.5 cm

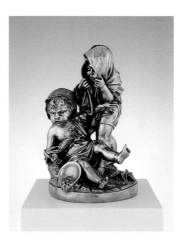

Figure 17. *Two Kids*, from *Statuary* series, 1986, stainless steel, edition of three, 58.4 x 37 x 37 cm

society. On one end, I had Bob Hope, and on the other end, I had Louis XIV. But I was really trying to show the history of art since the French Revolution. Also it was saying that if you put art in the hands of the masses—which Bob Hope was a symbol of—it'll become reflective of mass ego and eventually just become decorative. On the other end of the panoramic view, if you put art in the hands of a monarch, it'll reflect the monarch's ego and also eventually just become decorative.

Rabbit, made the same year, was art as fantasy; maybe you could say it was surrealist, but I thought of it as art as fantasy. The same year, I made *Two Kids*, which was art as morality, and *Doctor's Delight*, which was art as sexuality, and *Mermaid Troll*, which was art as mythology.

Then I did *Banality* [1988–89] for Ileana. That was in wood and porcelain and was a collage of dislocated images. In *Banality*, I was trying to tell people to have a sense of security in their own past, to embrace their own past. This was the most direct way that I started to speak about people not letting art be a segregator. I felt the bourgeoisie would embrace these images because all advertising at the time was really using a lot of dislocated im-

ages. If you think of a Newport commercial—with someone carrying a watermelon on their head and smiling or maybe playing a trombone—people should embrace this, and just kind of accept this within themselves.

After that, I made *Made in Heaven* [1989–91], and *Made in Heaven* was really about coming to appreciate the Baroque and the Rococo. I love Fragonard and Boucher. I also love Manet very much. I just wanted to make a body of work that was extremely romantic and in the Baroque and Rococo traditions. I never planned to make work that was going to be shocking. Masaccio's *Expulsion from Eden* was a very important painting to me as a basis for my *Made in Heaven* work. I believe very strongly that what I was doing was desexualizing the sexual aspect, which was explicit, and sexualizing things that are normally not sexualized, like the flowers and the animals.

Then I made *Puppy*. *Puppy*, for me, is a very baroque work, where I have a certain order and control in creating the piece, but, at the same time, eventually I have to give up all control. It's a very spiritual and joyous piece.

DS: You want the work to be joyous in impact. But it's also disturbing and ambivalent.

JK: Look at the *Rabbit*. It has a carrot to its mouth. What is that? Is it a masturbator? Is it a politician making a proclamation? Is it the Playboy Bunny?

DS: It's all of them.

JK: Yes, it's all of them.

DS: And the work is about that.

JK: Well, I think that great work—and I hope that my work does this—is chameleon. That it's chameleon for whatever cultures come after it. If it's going to sustain itself or be beneficial to people, it has to be able to adapt somehow and have meaning for them. I've tried to put things of interest in my work for *this* cultural climate, *this* society, but I hope that somehow I can hit into archetypes that continue to have meaning to peo-

ple. I think that the meanings change, but there's something at the core of the archetype that remains very important to the survival of humankind.

DS: I think that your work can be seen by some as essentially aesthetic rather than as essentially conceptual.

JK: David, actually, I see my work as the opposite. I see it as essentially conceptual. I think that I use aesthetics as a tool, but I think of it as a psychological tool. My work is dealing with the psychology of myself and the audience. "Aesthetics" on its own: I see that as a great discriminator among people, that it makes people feel unworthy to experience art. They think that art is above them. But there are basic aesthetics that I use to communicate.

I received such support in my interest in art from when I was just a child. The first things I did were from the newspaper. Every weekend there would be a section called "Cappy Dick," which was a little black-and-white cartoon. What you had to do was to cut that out of the newspaper, glue it onto another piece of paper, and extend the drawing and color it. I would

Figure 18. *Ushering in Banality,* from *Banality* series, 1988, polychromed wood, edition of three, 96.5 x 160 x 76.2 cm

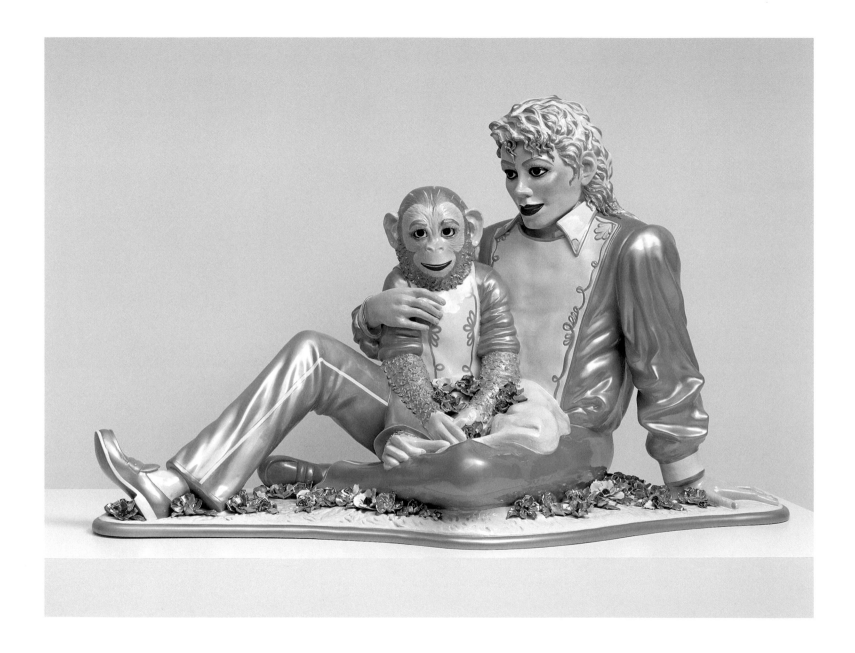

Figure 19. *Michael Jackson and Bubbles*, from *Banality* series, 1988, ceramic, edition of three, 100 x 180 x 82.5 cm

enter every weekend. I never won first prize—which was a set of ency-clopedias—but I'd always win a second or third prize, every week. And I loved doing that. I was always supported in doing that.

Eventually, I took art lessons. My first teacher was about eighty years old, and she was a wonderful woman. I'd go to her basement—I was about seven years old—and we would draw vases of flowers, in charcoal and pas-tel. Every afternoon, at the end of our session—about a six-hour session—she would take my drawing and say, "Okay." And she would redraw it. She'd take the eraser and say, "See the curve on that rose petal?" And she'd erase mine and draw it. "And do you see this color here? What happens there?" And she would teach by showing me how to create these illusions.

My father was an interior decorator and had a furniture store, and so I was brought up with an understanding of how color and different objects and things coming together could affect your emotions. My father loved the French provincial a lot, and in his showroom he would have different rooms: one would be a bedroom, another a dining room, another a kitchen. I would go back two weeks later and everything would have changed. Instead of being this French provincial bedroom, now it'd be a modern bedroom. This led to an understanding of how one's emotions are affected by these changes of color, texture, design. This was the beginning of my aesthetic understanding. So my father was very important to my ending up being an artist. My mother was also very influential and supportive. Her father was a city treasurer in York, Pennsylvania, where I came from, and he was involved in politics. I got more of a political sense from my mother's side. Aesthetic from my father, political from my mother.

DS: How did they react when you went into Wall Street?

JK: From the time that I was a child, after school I would go door to door selling things. I would sell gift-wrapping paper and bows and ribbons, or chocolates. I'd use mail order to buy twenty packages of something for a dollar a package, and then I'd sell it for two dollars. I always enjoyed that. I always liked the idea that I could make some money on my own, and my parents were always very supportive of it. I would take my money—

Figure 20. *Bourgeois Bust—Jeff and Ilona*, from *Made in Heaven* series, 1991, marble, edition of three, 120 x 71.1 x 53.4 cm

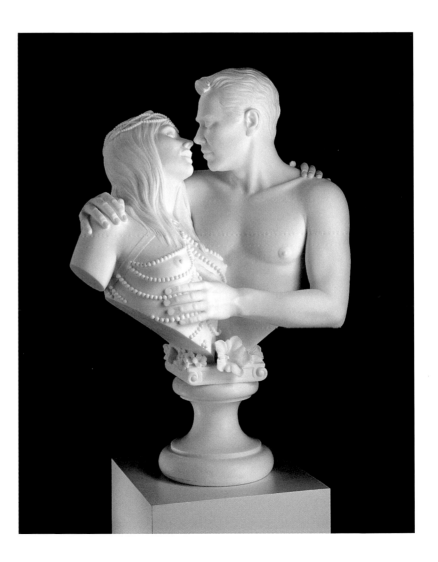

I had a very large road-racing set up in the attic of our home, and I'd always keep increasing it in size. I also enjoyed the interaction with people. I'd present the product, and people would buy it, and it was nice. I felt it was a way of meeting people's needs. One of the reasons that I want to make artworks is to meet people's needs and to give support to them.

So I was always good in sales. When I came to New York, I worked at the Museum of Modern Art at their membership-information desk. I realized that nobody was selling memberships, so I just decided, you know, people could upgrade their memberships, and we could bring in more money for the museum, and, actually, the people would get more benefits. If they paid only fifteen dollars more, they'd get like fifty dollars worth of books. So I started increasing membership by telling people they could upgrade. Eventually I started bringing in around a patron a week—just by talking to people when they'd come through the door. A couple of people I made patrons said, "You should come and work for me."

The work on Wall Street was really just sales. There were people who were specialists and just analyzed markets. I was never an analyst; I was a salesperson. I got licensed and registered to sell commodities and stocks and bonds, and that's what I did. The reason I did this was to make enough money to be able to make my artwork. I had no limit to the income that I could make. Making my vacuum-cleaner pieces cost about $3,000 each, and in the 1980s it was the only way that I could make enough money. I continued until I reached an emotional level where I could not think about anything else other than my work. I was with Smith Barney at the time, and I'd be on the phone, and—instead of prospecting to bring in a new client, or trying to have a client invest more money—I'd just be on the phone with Dr. Richard P. Feynman, Nobel Prize winner, talking to him about equilibrium, asking him how to make a permanent equilibrium. I think that when you reach that point where you can't do anything else other than your work, you just have to go for it. I was fortunate enough that, when that really occurred to me, there was enough interest in my work that I was able to just do my work and receive support from the art world.

I feel salespeople are on the front line of culture. Society changes so much, and sales has changed a lot. I mean, there used to be a time when

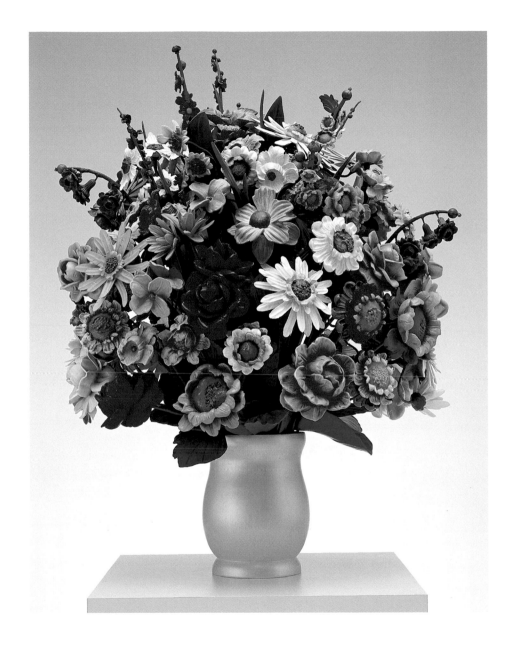

Figure 21. *Large Vase of Flowers*, from *Made in Heaven* series, 1991, polychromed wood, edition of three, 1.3 x 1.1 x 1.1 m

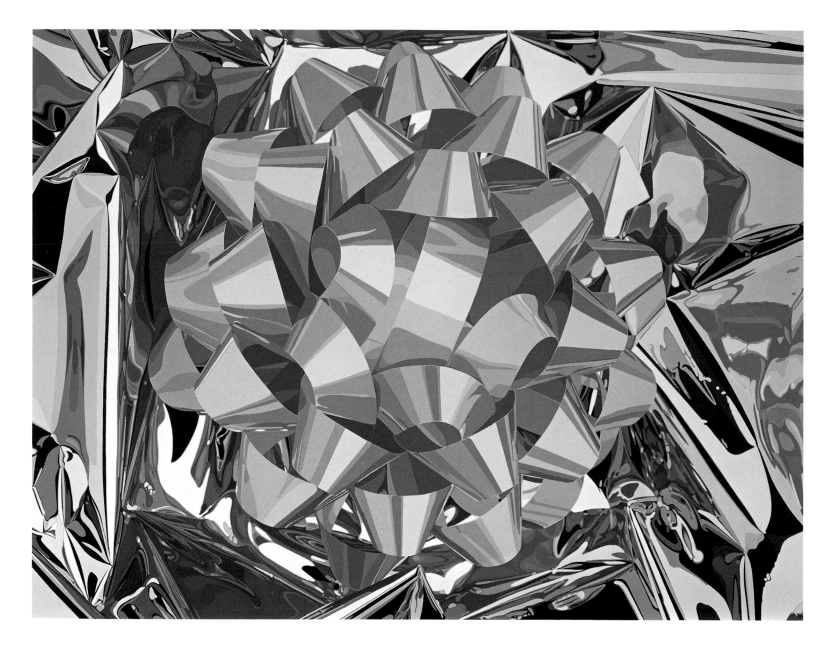

Figure 22. *Pink Bow*, from *Celebration* series, 1995–97, oil on canvas, 2.7 x 3.5 m. Private collection

a salesman would go door to door; in America, the knock on the door meant the Hoover man was there. One of the reasons I did my vacuum-cleaner pieces was the door-to-door salesman. Even in *Celebration*, a painting like *Pink Bow* [1995–97] makes you think about a birthday or a gift, but it's also about my own history of door-to-door selling. This is what I would buy and sell to people. And candies. Now, I haven't painted candies, but there's a lot of food in the work. I think food relates back to more of these archetypal things, the bare essentials we need to survive. Each of the *Easyfun* paintings has an aspect of food, whether it's whipped cream, or it's a cookie, or it's Cheerios or milk. And in the *Celebration* paintings, I have cake, I have popcorn, I have bread with egg, I have an eggshell.

DS: Your ambition is to nourish.

JK: I feel incredibly strong when I make my artwork, and so art for me is about increasing my own perimeters in life. And hopefully my work gives viewers a sense of the possibilities for their own futures as much as it does for mine.

Dream Machine

...........................

ROBERT ROSENBLUM

July–August 2000. During these summer months I turned up regularly at Jeff Koons's factory-sized studio (shades of Andy Warhol!) on the corner of Broadway and Houston Street, a central hub of SoHo. My mission was to watch him at work, to see how he compiled his sources, recreated them in his imagination, and materialized them in the seven billboard-sized canvases (3 x 4.3 meters each) of *Easyfun-Ethereal*, a new series that opens fresh vistas on his trademark marriage of computerized precision and free-floating fantasy. Both of these components—state-of-the-art technology and a populist dreamworld of the senses—are conspicuous muses in Koons's working spaces. Entering his studio is like entering a business office. Computers, Xeroxes, files, and a busy staff replace paint tubes, brushes, stretchers. We seem to have exchanged the artist's ivory tower for the assembly line, laboratory world of the commercial designer who invents the visual delirium that surrounds us, those explosive and ephemeral riots of gaudy artifice we usually screen from our eyes.

Koons revels in such commonplace facts as the extravagant ways in which dry cereal is packaged to make kids grab it off the supermarket shelf. (He has been contacted by Flake World Publishing, an organization dedicat-ed to the encyclopedic collecting of vintage cereal boxes.) If he sees a full-page ad designed to plunge us into a whirlpool of pleasure set in motion by the addition of almonds to chocolate (in the words of the caption, "When almonds are in . . . chocolate takes a nutty spin"), he pores over it, and then cuts it out for future reference. If, thumbing through more high-priced ads, he notices the way Cacharel's lingerie promotion un-dresses a ravishing French model, setting aloft her tricolor bra and panties in computerized winds, he puts that in yet another stockpile. Way back in the 1960s, of course, artists like Lichtenstein and Warhol were scruti-nizing the seamiest, most low-budget advertising imagery as grass-roots retorts to the ivory-tower pretensions of their arty colleagues. Koons, how-ever, has chosen to embrace a totally different world of the commercial senses—luxuriously synthetic fantasies of creamy textures, electronic rain-bows, magical buoyancy—all recorded in his vast and ongoing accumulation of source material clipped from an international anthology of glossy mag-azines. The pages that captivate him are those that rush us from one enchantment to another, from the pleasures of childhood food, fun, and games (stuffed animals, water slides, Pokémon characters, sandwiches sport-ing happy faces made of sliced-olive eyes and mustard smiles, a

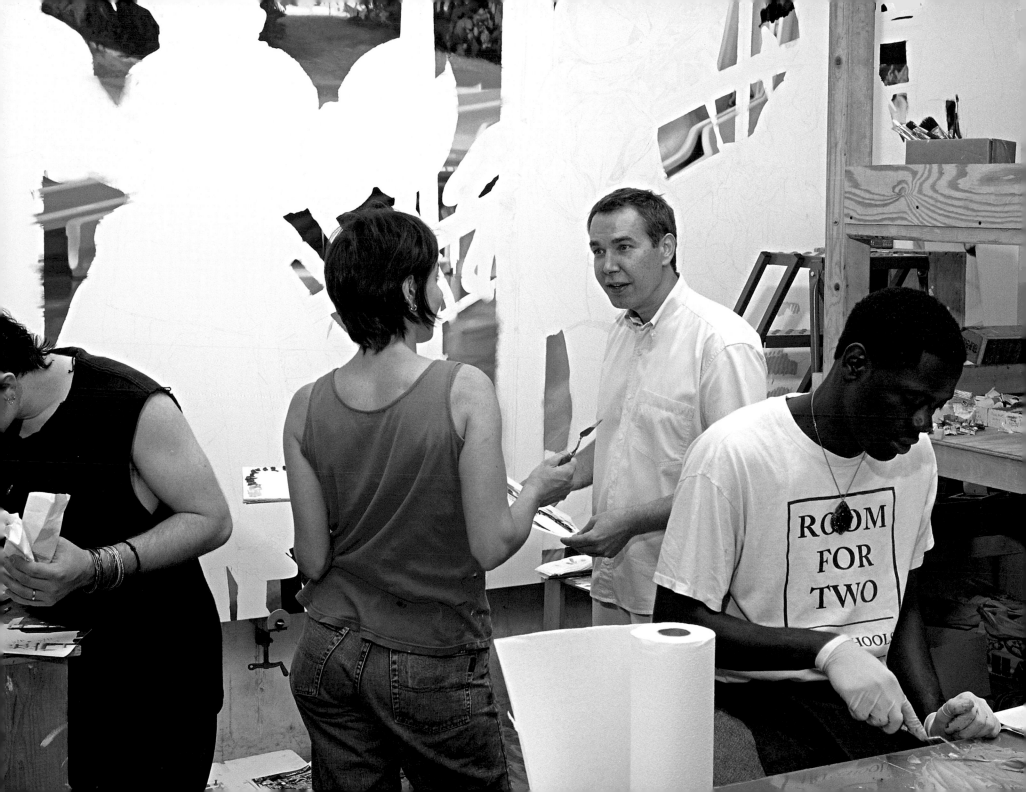

Thanksgiving turkey made of ice cream) to the pleasures of grown-up lust (wafting visions of lipsticked mouths, silk-smooth legs, perfumed hair, nail-polished toes). In other words, the range embraces two of the constant obsessions in Koons's art—kid stuff and sex.

I was at first dumbfounded by what seemed the crazy abundance and diversity of this magpie collection of personal photographs, magazine tear sheets and brochures for popular tourist attractions, both man-made (the amusement park in Hershey, Pennsylvania, near Koons's own hometown, York) and natural (Indian Echo Caverns, also near Hershey, as well as the Frasassi Caves, between Assisi and Ancona in Italy). It all looked like a giant scrap heap of the pages you usually flip past on the way to the article or the information you're looking for—an infinity of visual seductions that might include sexy Greek models in bikinis, a cascade of orange juice, a disembodied eyelid covered with purplish-gray eyeshadow, a sharp-focus photo of stalactites, a toy abacus with beads in kindergarten colors. But as I watched Koons wax poetic about this or that specimen in his hand-picked anthology of favorites, I also saw him putting order into what most of us censor out of sight as visual junk. For each of the seven paintings

in the series, he gradually compiled a folder of clippings later to be reshuffled and morphed on a computer screen in unexpected ways, forming a fluid collage of wildly disparate parts that finally clicks into place as an inevitable fusion of shape and image.

Slowly, in fact, I discerned method in the madness, realizing, for example, that a recurrent form runs through almost all of the paintings—namely, a whirlwind spiral that appears in many reincarnations: long, shimmering streams of straight or braided hair; the vertiginous coils of a roller coaster; the liquid stream poured from a bottle of Revlon Cherry Crush nail polish, caught in a midair photo flash. To describe such childlike flights into the liberating skies of Peter Pan, Koons reaches for the word "ethereal," a term that evokes both his efforts to make us literally soar through his dreamlike spaces and his more abstract ambitions "to use the Baroque to show the public that we are in the realm of the spiritual, the eternal."[1] In fact, in surprising ways, the intricate, gravity-defiant asymmetries of many of Koons's restlessly curving shapes—the curls of a salad green, the undulant contours of breeze-blown hair—revive the language of the most spectacularly ornate manifestations of German Baroque and Rococo art,

"**The Easyfun-Ethereal paintings are very layered. My interest has always been to create art that can change with any culture or society viewing it. When I look at the paintings and realize all the historical references, it's as if, for a moment, all ego is lost to meaning.**"

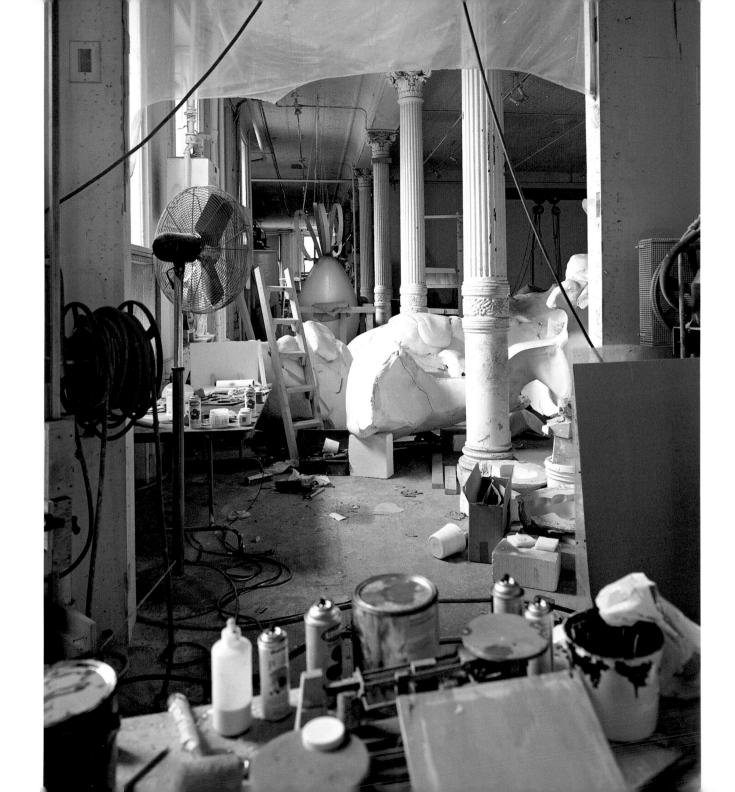

a style that has been whimsically, but usefully, referred to as "barococo." This gorgeous corner of art history has offered constant inspiration for Koons, who has plucked many quotations from the gilt flames of Rococo ornament, from the polychrome stucco cherubs that flutter amid Rococo heavens, and from the eighteenth-century church frescoes he frequently visited during his Munich-based sojourns in the early 1990s. (Just this year, for example, he borrowed an image of Saint Benedict from one of Martin Knoller's painted vaults in Balthasar Neuman's Neresheim Abbey.) And of course, this style of joyful, sensuous excess, traditionally so alien to twentieth-century minimalist taste, also laid the foundations for much of the twentieth-century kitsch that has always triggered Koons's imagination.

Just as the language of the Rococo often hovers about Koons's work, so too do many twentieth-century artists make occasional appearances. One of the most surprising examples, Pollock, is made explicit in the huge canvas smilingly titled *Blue Poles* in homage to a key painting of 1952 by the venerable master of elitist art. A color reproduction of Pollock's painting figures in one of the preparatory folders, side by side with other source material that probably would have reminded no one but Koons of this museum classic. Yet his point is delightfully obvious. His huge painting also sucks us into a universe of breathtaking gyrations, achieved not through material skeins of turbulent paint, but through a brushless replication of a photo of the looping circuits of a metal roller coaster, propped up on, quite literally, blue poles. And as a further gloss on Pollock's plunge into a world that keeps us spinning and bobbing, Koons catches the coaster car in midair, as it shifts seamlessly from right side up to upside down. To add to this *perpetuum mobile*, a quartet of prancing and dancing figures in kids' party costumes—lobster, frog, octopus, bat—twist and turn in the foreground, looking as weightless as the spiraling tracks behind them. And in the remote background, the roller-coaster theme is amplified by a quartet of blue water slides that, as in a Pollock, contribute to the confusing but exhilarating sense of an infinity of spatial layers simultaneously expanding and contracting, rushing us from near to far. It's an effect achieved still more directly in *Grotto*, where a dizzying vortex (a computer metamorphosis derived from an image of a chocolate swirl) plunges us into the distant depths of a natural cave, creating a science-fictional voyage that sweeps into its path a tornado of golden locks, in a new kind of baroque ecstasy that wafts us from earth to heaven.

Characteristically, Koons keeps upping the ante for spatial density here using at least four or five layers of flying objects vanishing and reappearing in an electronic spin cycle. An underlying carpet of nature—a verdant landscape, an unfathomably deep cave—provides a subliminal foundation to some of Koons's technological dream images, rooting them mysteriously to an unpolluted site on Mother Earth. These reminders of a natural world of leaves and stone give an additional edge to the totally synthetic hues that pass through his computerized ether, so that the green of grass or the blue of sky sets into even sharper relief the electronic yellows, pinks, reds, oranges of hair, lips, flesh, food. Koons's chromatics defy verbal description, transcending old-fashioned organic metaphors: "coral pink," "peacock blue," "oxblood red" will no longer do.

Lips produces similar sensations—an erotic dream of moistened, floating lips, both closed and parted; a drifting necklace made not of pearls but of kernels of canned corn; a serpentine swirl of orange juice that, were it not for one cloud-borne orange segment, would look almost as abstract as Pollock's poured pigments. And Pollock's vision of infinitely expansive, oceanic spaces pertains as well to *Hair with Cheese*, another hymn to the commercial goddess of sex and love, in which the chromatic and tactile seductions of cosmeticized hair, eyes, and mouth float and heave over a spring landscape like an erotic mirage. Here, too, Koons's growing preference for body fragments—the fetishes of advertising lure—is apparent, especially his delight in rendering the immaculate hairdo detached from its head like a mannequin's wig, a grotesque effect recalling those faceless, costumed amusement-park props that leave a cutout to be filled by the head of a fun-loving visitor posing for a snapshot.

However often Pollock's turbulent ghosts haunt these immaterial spaces, Koons's art-historical pedigree usually evokes ancestors of the kind more obviously involved with dreams and body parts—the Surrealists. In discussing the commercial sources for these seven paintings, Koons would often refer to Magritte and Dalí as venerable prophets of his current enterprise. For instance, he mentioned enthusiastically Magritte's *The False*

Mirror (1928), a painting of a cloudscape magically seen through a disembodied eye—an image recently conspicuous in New York in an ad for the Museum of Modern Art's exhibition *Making Choices*. Koons's affinity to Magritte is as predictable as his frequent invocation of Dalí, whose metamorphic anatomies and warped spatial infinities also provide a background for computer fantasies. And the Pop generation turns up often in the repertory of artists Koons responds to: the immaculate, dust-proof precision of Lichtenstein, for one, and, even closer as a forerunner, Rosenquist. In a long conversation with Rosenquist published in *Parkett* earlier this year,[2] we learn from Koons how, when working at the Museum of Modern Art in 1978, he was smitten by Rosenquist's *Marilyn Monroe I* (1962), a painting that, looked at in the context of this new series, seems especially prophetic, with its upside-down and right-side-up fragments of nose, eyes, and lips, and its spray-painted, Day-Glo replications of the artificially luminous, impersonal facture of mechanical image-making. In the same conversation, Rosenquist's reference to some of the components of his recent wrap-around mural for the Deutsche Guggenheim Berlin (*The Swimmer in the Econo-Mist*, 1998)—cereal boxes and "a thing that looks like clothes in a washing machine in tumult"—provides another

connection with Koons's current picks from the synthetic world around us. There are comparable connections to be made between Koons and another heir of Rosenquist, David Salle, also a major scavenger from popular and elite visual culture who, like a channel surfer, explores layered effects of shuffled, translucent imagery.

Koons looks toward younger generations as well. The creatures and things in inhabiting *Easyfun-Ethereal* join forces with the new progeny of mythic, artificial beings, the alien humanoids who have been populating many recent installations and videos. And appropriate to this increasingly synthetic world, Koons has virtually annihilated the traditions of savoring an artist's personal touch, which now exists only in conceptual, not material, terms. In this new role for the artist, Koons has become an impresario in charge of a high-tech production process supervised by hired experts. Colors are not mixed and altered on the artist's palette; limbs and faces are not recontoured or repositioned by the artist's brush and pencil; additional images are not inserted by hand. All of this once manual work is done on a computer screen, constantly readjusted under the artist's surveillance to create unfamiliar refinements of hue, shape, and layering. Then,

"Contemporary artists have so many visual options and technologies to work with, but the medium is never the message, the message is the gesture."

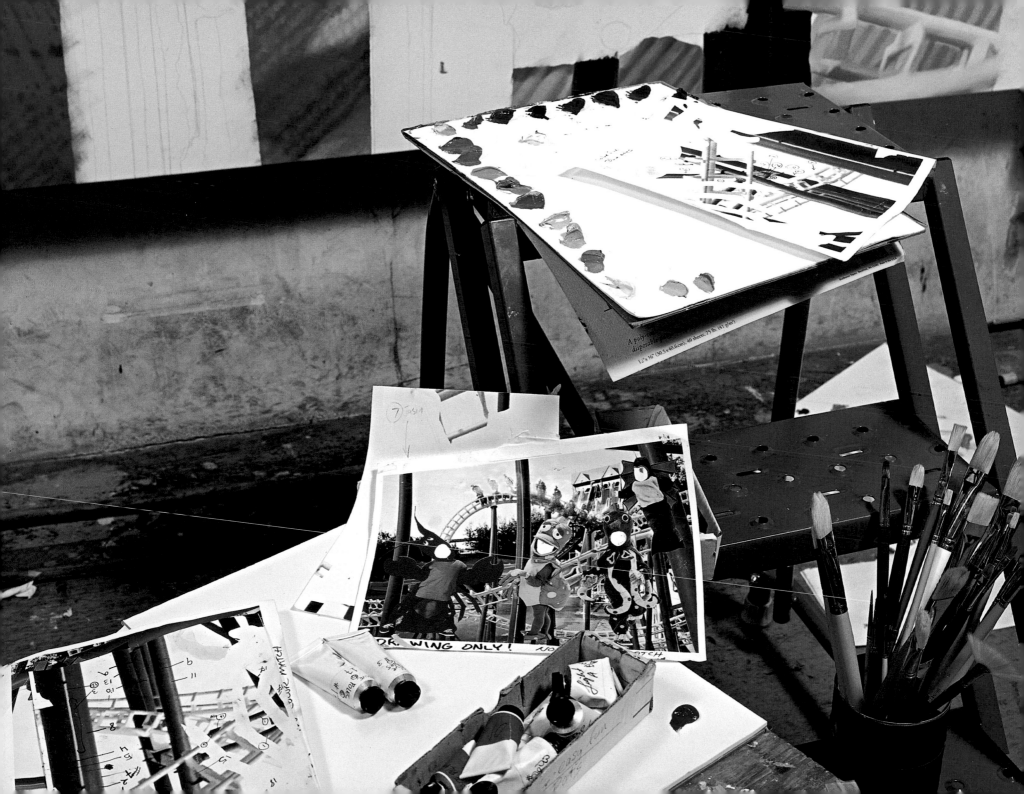

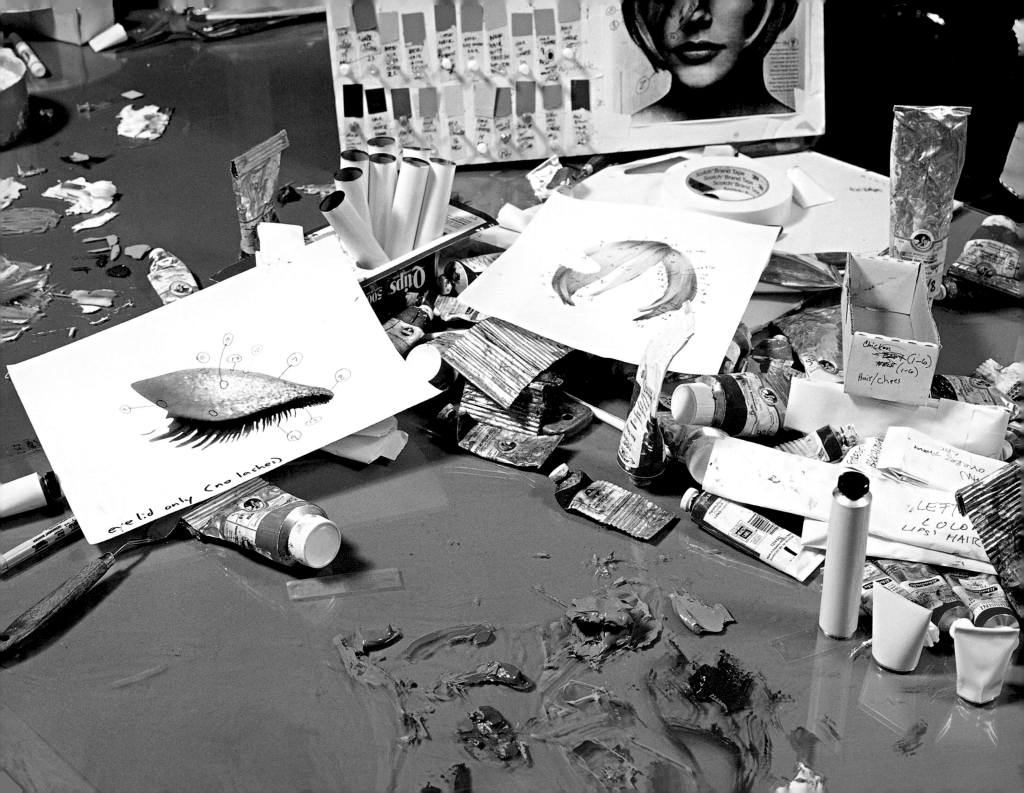

in the backroom of the studio, the final, approved printout is given to a large, highly skilled staff who, with the clinical accuracy of scientific workers and with an industrial quantity of brushes, paint tubes, and color codes, replicate exactly the hues, shapes, and impersonal surfaces of the computer image through the traditional technique of oil on canvas. What begins as advertising photography is then transmuted into an electronic product, which in turn is translated back into an old-fashioned medium. Perhaps this is as it should be. To be sure, Koons has fully joined the world of computer imagery, these works could not have been created in any other way. But unexpectedly, they also bear the weight of tradition. Not only are they full of memories of the history of twentieth-century painting, but, even after going through the magic looking glass of the computer, they return to the world of pigment, canvas, and stretcher. As usual, Koons rushes to embrace the future, while keeping one foot firmly in the past.

Notes

1. *The Jeff Koons Handbook* (London: Anthony d'Offay Gallery, 1992), p. 106.

2. Jeff Koons and James Rosenquist, "If You Get a Little Red on You, It Don't Wipe Off," *Parkett*, no. 58 (2000), pp. 36–43.

Plates

Plate 1. *Lips,* 2000, oil on canvas, 3 x 4.3 m

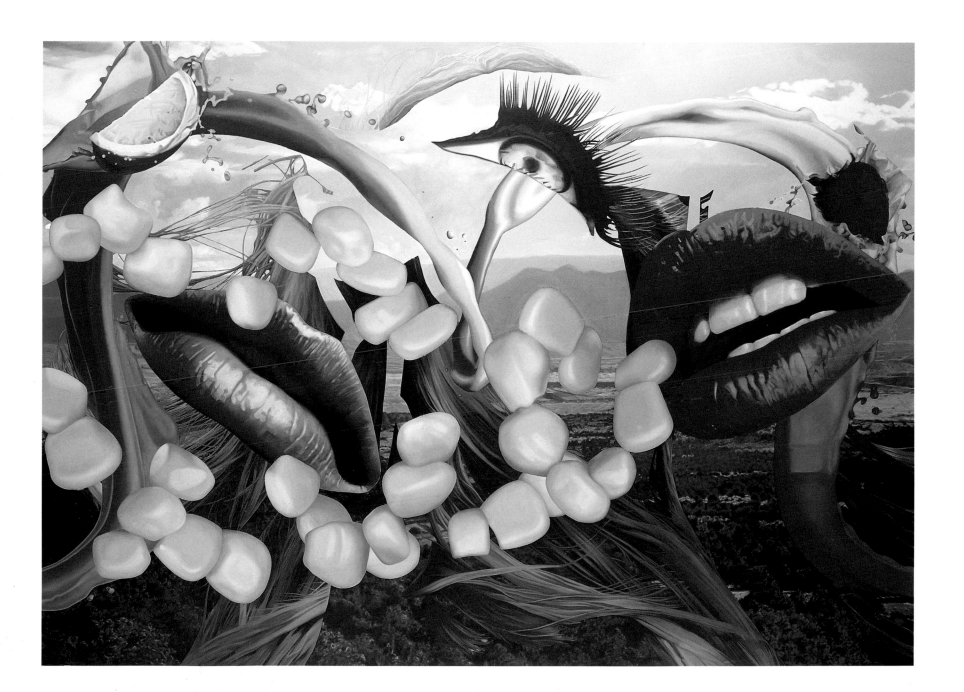

Plate 2. *Hair with Cheese*, 2000, oil on canvas, 3 x 4.3 m

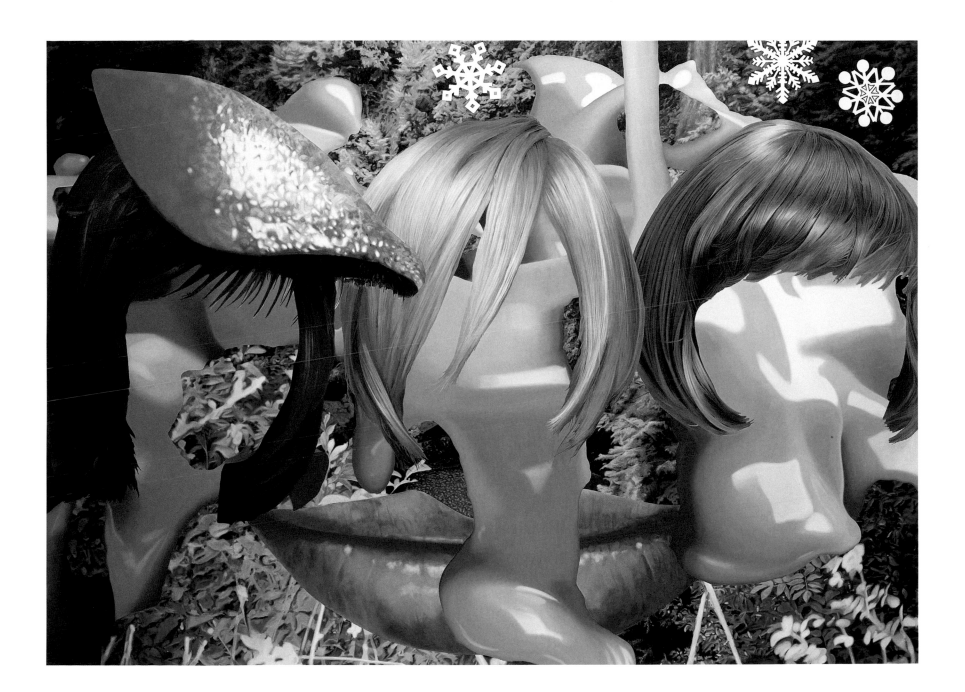

Plate 3. *Sandwiches*, 2000, oil on canvas, 3 x 4.3 m

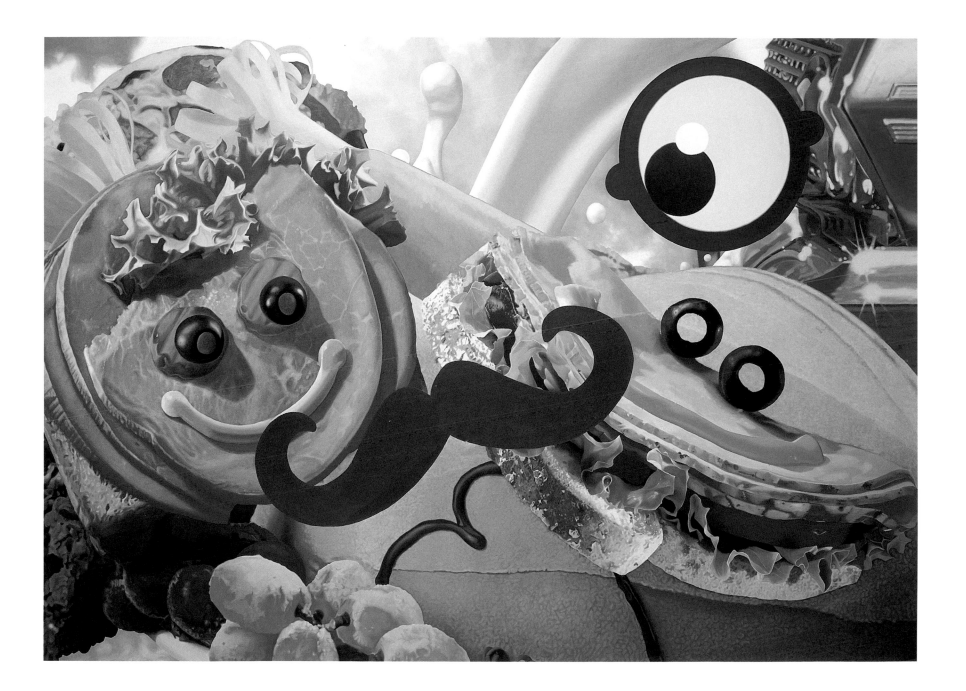

Plate 4. *Niagara*, 2000, oil on canvas, 3 x 4.3 m

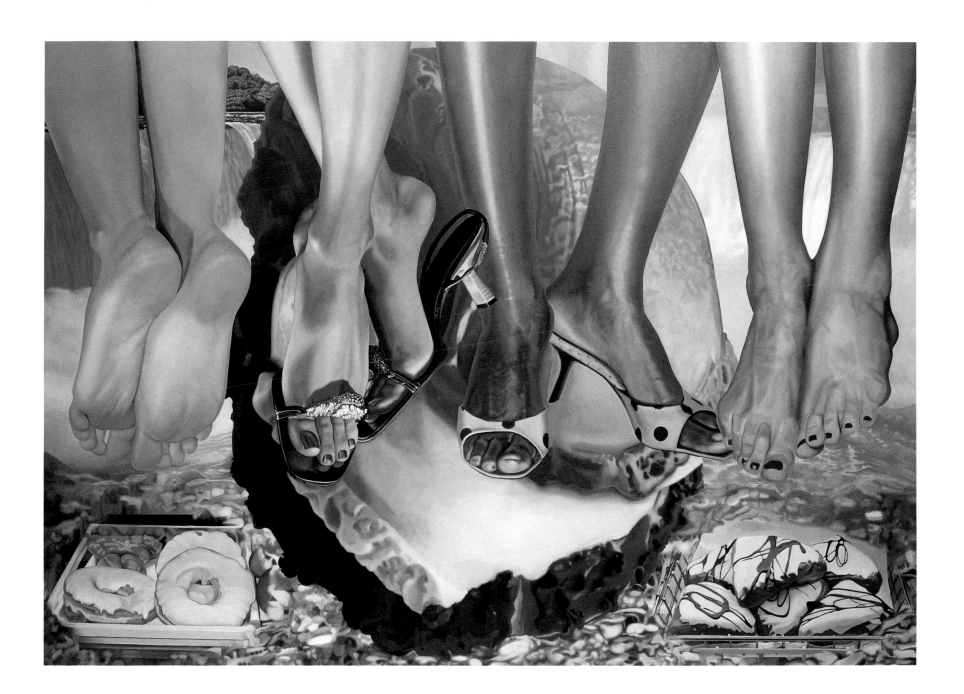

Plate 5. *Bluepoles*, 2000, oil on canvas, 3 x 4.3 m

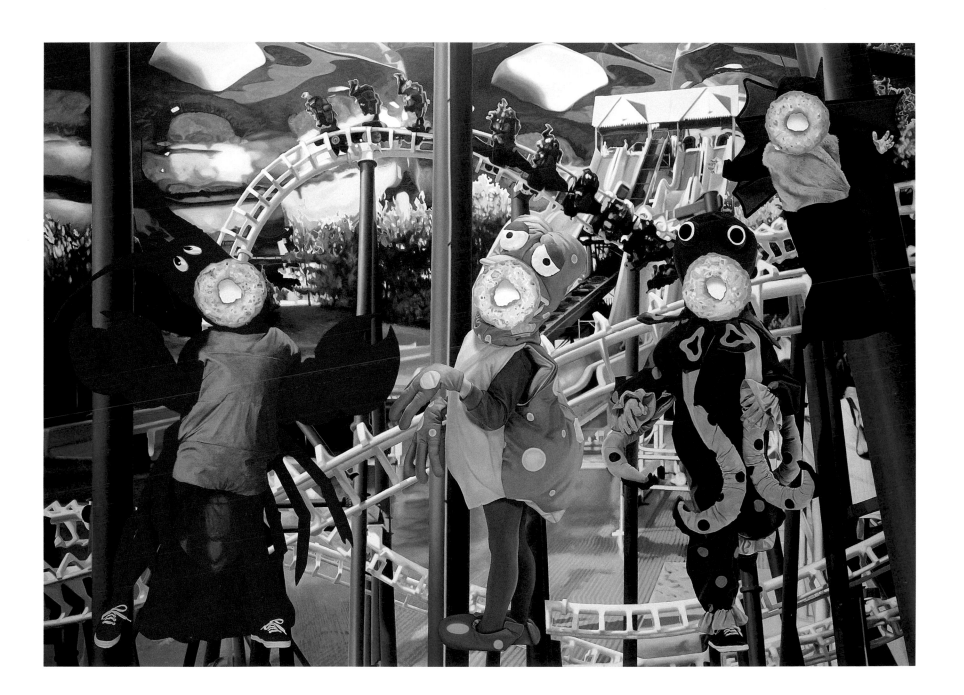

Plate 6. *Mountains*, 2000, oil on canvas, 3 x 4.3 m

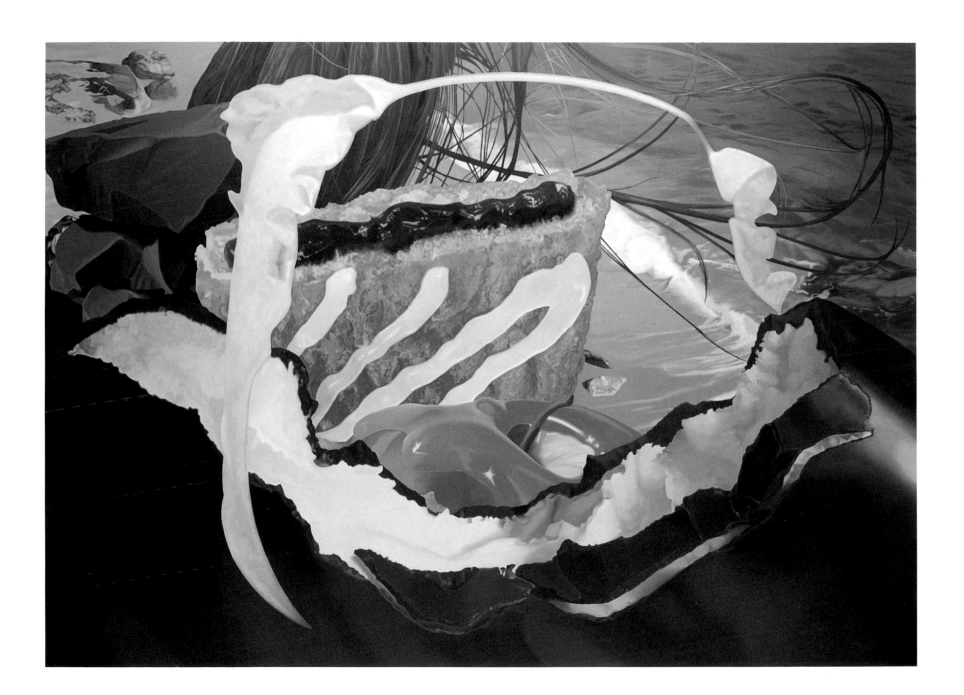

Plate 7. *Grotto*, 2000, oil on canvas, 3 x 4.3 m

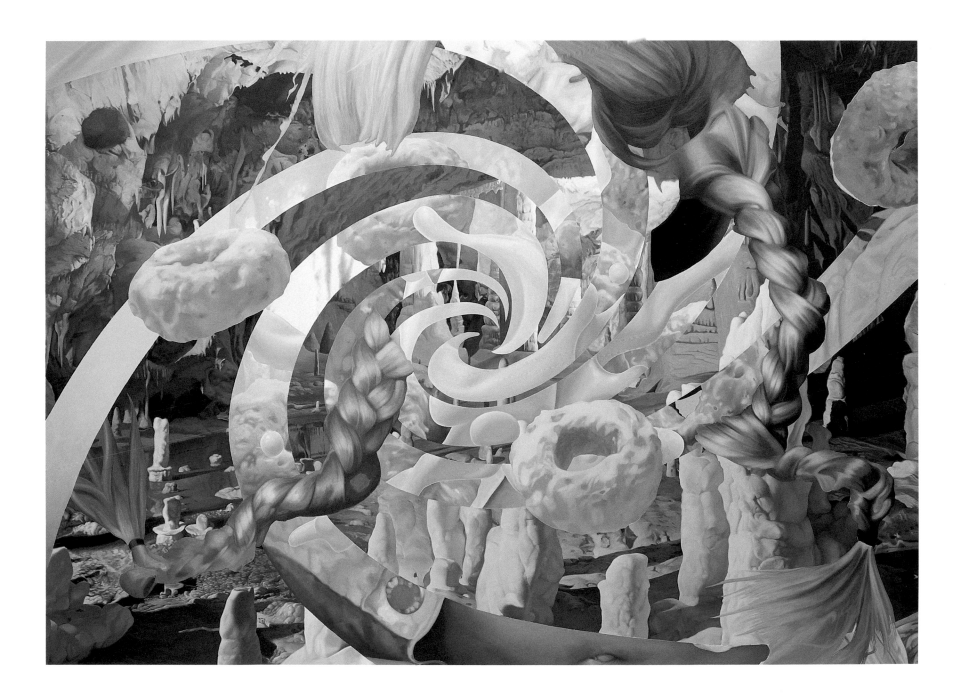

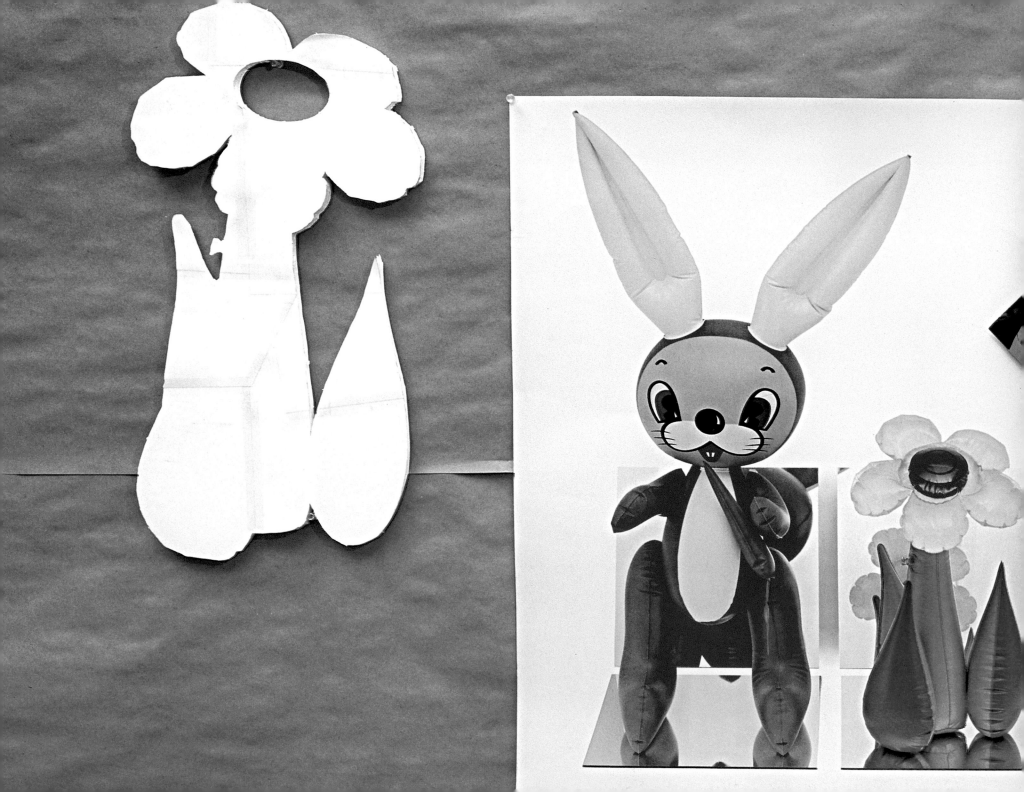

Selected Solo Exhibitions

..

1980

New Museum of Contemporary Art, New York, *The New* (window installation at 65 Fifth Avenue), May 29–June 26.

1985

International with Monument, New York, *Equilibrium*, June 12–July 14. Also shown at Feature Gallery, Chicago, Sept. 13–Oct. 12.

— Indiana, Gary. "Jeff Koons at International with Monument." *Art in America* (New York) 73, no. 1 (Nov. 1985), pp. 163–64.

— Indiana, Gary. "Paradigms of Dysfunction." *The Village Voice* (New York), June 11, 1985, p. 91.

1986

Daniel Weinberg, Los Angeles, *Luxury and Degradation*, July 19–Aug. 16. Also shown at International with Monument, New York, through Oct. 12.

— Brenson, Michael. "Art: Jeff Koons." *The New York Times*, Oct. 10, 1989, p. C32.

— Levin, Kim. "His Best Shot." *The Village Voice* (New York), Oct. 14, 1986, p. 96.

— Pincus-Witten, Robert. "Entries: First Nights." *Arts* (New York) 61, no. 5 (Jan. 1987), pp. 44–45.

— Salvioni, Daniela. "Jeff Koons, International with Monument." *Flash Art* (Milan), international edition, no. 131 (Dec. 1986–Jan. 1987), p. 89.

1987

Daniel Weinberg, Los Angeles, *The New: Encased Works 1981–1986*, Dec. 5, 1987–Jan. 9, 1988.

1988

Museum of Contemporary Art, Chicago, *Jeff Koons: Works 1979–1988*, July 1–Aug. 28.

— Palmer, Laurie. "Jeff Koons, Museum of Contemporary Art." *Artforum* (New York) 27, no. 2 (Oct. 1988), p. 153.

Galerie Max Hetzler, Cologne, *Banality*, Nov. 13–30. Also shown at Sonnabend Gallery, New York, Nov. 19–Dec. 29; and Donald Young, Chicago, Dec. 3, 1988–Jan. 7, 1989.

— Brenson, Michael. "Greed Plus Glitz, with a Dollop of Innocence." *The New York Times*, Dec. 18, 1988, Arts and Leisure section, pp. 41, 44.

— Chua, Lawrence. " Jeff Koons: 'Popples,' an Appropriate Icon for an Era of Gross Inanity." *Flash Art* (Milan), international edition, no. 144 (Jan.–Feb. 1989), pp. 112–13.

— Cooke, Lynne. "New York, Sonnabend Gallery, Jeff Koons." *Burlington Magazine* (London) 131, no. 1,032 (March 1989), pp. 246–47.

— Daniel, David. "Jeff Koons." *Art and Antiques* (New York) 6, no. 3 (March 1989), p. 38.

— Heartney, Eleanor. "Jeff Koons, Sonnabend." *ArtNews* (New York) 88, no. 2 (Feb. 1989), p. 138.

— Levin, Kim. "The Evil of Banality." *The Village Voice* (New York), Dec. 20, 1988, p. 115.

— Magnani, Gregorio. "Letter from Germany." *Arts* (New York) 63, no. 9 (May 1989), pp. 118–19.

— Mahoney, Robert. "Miracle on W. Broadway." *New York Press*, Dec. 9, 1988, pp. 15–16.

— McCracken, David. "Cuteness with an Edge in Jeff Koons's Work." *The Chicago Tribune*, Dec. 16, 1988, p. 75.

— Perl, Jed. "Jeff Koons." *The New Criterion* (New York) 7, no. 7 (March 1989), p. 51.

— Pincus-Witten, Robert. "Entries: Concentrated Juice and Kitschy Kitschy Koons." *Arts* (New York) 63, no. 6 (Feb. 1989), pp. 34–39.

— Smith, Roberta. "Subtle Ways to Eat Your Cake and Have It Too." *The New York Times*, Oct. 8, 1989, Arts and Leisure section, pp. 35–36.

— Wood, Paul. "Jeff Koons, Sonnabend." *Oxford Art Journal* 12, no. 2 (1989), pp. 108–09.

1989

Galerie 'T Venster, Rotterdamse Kunststichting, Rotterdam, *Jeff Koons—Nieuw Werk*, Jan. 13–Feb. 9.

1991

Galerie Max Hetzler, Cologne, *Made in Heaven*, Nov. 15–Dec. 14. Also shown at Sonnabend Gallery, New York, Nov. 23–Dec. 21; Galerie Lehmann, Lausanne, March 5–May 6, 1992; and Christophe Van de Weghe, Antwerp, Feb. 12–March 29, 1992.

— Adams, Brooks. "Jeff Koons at Sonnabend." *Art in America* (New York) 80, no. 3 (March 1992), pp. 117–18.

— Bourriaud, Nicolas, and Brian D'Amato. "Jeff Koons: Catch as Kitsch Can." *Flash Art* (Milan), international edition, no. 162 (Jan.–Feb. 1992), pp. 124, 176.

— Kimmelman, Michael. "Jeff Koons, Sonnabend Gallery." *The New York Times*, Nov. 29, 1991, p. C28.

— Perl, Jed. "Art: Amateurs and Others." *The New Criterion* (New York) 10, no. 5 (Jan. 1992), pp. 39–40.

— Plagens, Peter. "The Young and the Tasteless." *Newsweek* (New York), Nov. 18, 1991, p. 80.

— Pozzi, Lucio. "Jeff Koons e Cicciolina, erotismo alla saccarina." *Il Giornale dell'Arte* (Rome), no. 97 (Feb. 1992), p. 26.

— Sprinkle, Annie. "Hard-Core Heaven: Unsafe Sex with Jeff Koons." *Arts* (New York) 66, no. 7 (March 1992), pp. 46–49.

— Stevens, Mark. "Adventures in the Skin Trade." *The New Republic* (New York), Jan. 20, 1992, pp. 29–32.

— Tully, Judd. "Jeff Koons's Raw Talent: In New York, an X-Rated Exhibition." *The Washington Post*, Dec. 15, 1991, pp. G1, G3.

— Woodward, Richard B. "Jeff Koons, Sonnabend." *ArtNews* (New York) 91, no. 2 (Feb. 1992), p. 122.

1992

Stedelijk Museum, Amsterdam, *Jeff Koons*, Nov. 28, 1992–Jan. 3, 1993. Also shown at Aarhus Kunstmuseum, Aarhus, Denmark, Jan. 22–Feb. 28, 1993; and Staatsgalerie Stuttgart, March. 12–April 18, 1993. Exh. cat., with texts by Gudrun Inboden and Peter Schjeldahl (in Dutch, German, and English).

— Veelen, Ijsbrand van. "Jeff Koons, Stedelijk, Amsterdam." *Flash Art* (Milan), international edition, no. 169 (March–April 1993), p. 110.

— Waldmann, Susann, and Antonio Seidemann. "Crónica de Alemania: Retrospectiva de Jeff Koons en Stuttgart." *Goya* (Madrid), nos. 235–36 (July–Oct. 1993), pp. 110–11.

San Francisco Museum of Modern Art, *Jeff Koons*, Dec. 10, 1992–Feb. 7, 1993. Also shown at Walker Art Center, Minneapolis, July 10–Oct. 3, 1993. Exh. cat., with texts by John Caldwell, Jim Lewis, Daniela Salvioni, and Brian Wallis.

— Baker, Kenneth. "The Message in Koons's Kitsch." *The San Francisco Chronicle*, Dec. 10, 1992, p. D1.

— Bortolotti, Maurizio. "Jeff Koons, San Francisco Museum of Modern Art" (review of exhibition catalogue). *Domus* (Milan), no. 754 (Nov. 1993), p. xv.

— Haskin, Pamela. "The Real Cliché." *The New Art Examiner* (Chicago) 21, no. 4 (Dec. 1993), pp. 16–19.

— Hughes, Robert. "The Princeling of Kitsch." *Time* (New York), Feb. 8, 1993, pp. 78–80.

— Knight, Christopher. "Jeff Koons: A Scrubbed New Life." *The Los Angeles Times*, Dec. 14, 1992, pp. F1, F12.

— Lufkin, Liz. "Koons' Artistic Circus." *The San Francisco Chronicle*, Dec. 10, 1992, pp. B3–B4.

— Rubenstein, Steve. "Getting too Close to the Inexplicable." *The San Francisco Chronicle*, Jan. 8, 1993, p. D18.

1994

Anthony d'Offay Gallery, London, *Jeff Koons: A Survey 1981–1994*, June 11–July 30, 1994.

— Bevan, George. "Jeff Koons Graces d'Offay." *Art Newspaper* (New York) 5, no. 39 (June 1994), p. 38.

— Craddock, Sacha. "Galleries Choice: Selected London Exhibitions of Contemporary Art." *The Times* (London), June 28, 1994, p. 33.

— Januszczak, Waldemar. "Kitsch and Sink." *Sunday Times* (London), July 10, 1994, section 10, pp. 14–15.

— Norman, Geraldine. "Showman Presents Dazzling Display of Crafted Vulgarity." *The Independent* (London), June 27, 1994, p. 3.

— Packer, William. "Hung, But by Its Own Petard." *Financial Times* (London), June 21, 1994, Arts section, p. 17.

1997

Galerie Jérôme de Noirmont, solo exhibition, Sept. 30–Nov. 29.

— Attias, Laurie. "Jeff Koons, Jérôme de Noirmont." *ArtNews* (New York) 97, no. 1 (Jan. 1998), pp. 142–44.

— Benhamou-Huet, Judith. "Jeff Koons: de Wall Street au Pop Art." *Les Echos* (Paris), Sept. 12, 1997, p. 58.

1998

Anthony d'Offay Gallery, London, *Jeff Koons: Encased Works*, Mar. 13–April 23 1998.

— Searle, Adrian. "Arts Visual: All Played Out." *The Guardian* (London), April 7, 1998, section G2, pp. 10–11.

1999

Sonnabend Gallery, New York, *Easyfun*, Nov. 13, 1999–Feb. 15, 2000.

— Gingeras, Alison. "Jeff Koons, Sonnabend Gallery." *Art Press* (Paris), no. 254 (Feb. 2000), pp. 12–14.

— Smith, Roberta. "Jeff Koons–Easyfun." *The New York Times*, Dec. 17, 1999, p. 47.

— Viveros-Fauné, Christian. "Jeff Koons: Easyfun." *New York Press*, Dec. 8, 1999, p. 26.

Deste Foundation, Athens, *Jeff Koons, A Millennium Celebration*, Dec. 15, 1999–May 15, 2000.

2000

Rockefeller Center, New York, *Puppy*, June 6–Sept. 5.

— Christiansen, Richard. "Koons' Puppy3 Is Bow-Wow 'Art' Indeed." *The Chicago Tribune*, July 9, 2000, p. C1.

— Dewan, Shaila K. "No Walking, Just Watering for This Puppy." *The New York Times*, June 6, 2000, p. B5.

— Douglas, Sarah. "Sit . . . Stay . . . Good Dog! A Gentle Giant Lands in Rockefeller Center." About.com, Contemporary Art section, July 28, 2000.

— Owen, Frank. "Reign of Terrier." *People Weekly*, July 3, 2000, pp. 130–31.

— Saltz, Jerry. "Jeffersonian Koons." *The Village Voice* (New York), June 27, 2000, p. 137.

— Smith, Roberta. "A New Dog in Town, Steel and Sprouting." *The New York Times*, June 8, 2000, p. E1.

— Smith, Roberta. "Stretching Definitions of Outdoor Sculpture." *The New York Times*, July 28, 2000, pp. E27, E29.

— Van Dusen, Lisa. "Meeting New York's Version of Puppy Love." *The Ottawa Citizen*, June 4, 2000, p. A16.

Selected Bibliography

"Interviews and Statements" is arranged chronologically. "Books, Articles, and Essays" is arranged alphabetically. Book entries are followed by related book reviews. For information about exhibition catalogues and exhibition reviews, see the exhibition history.

Artist's Project

"Baptism." *Artforum* (New York) 26, no. 3 (Nov. 1987), pp. 101–08.

Interviews and Statements

"From Criticism to Complicity" (panel discussion moderated by Peter Nagy, with Ashley Bickerton, Peter Halley, Jeff Koons, Sherrie Levine, Haim Steinbach, and Philip Taaffe). *Flash Art* (Milan), international edition, no. 129 (summer 1986), pp. 46–49.

Siegel, Jeanne. "Jeff Koons: Unachievable States of Being." *Arts* (New York) 61, no. 2 (Oct. 1986), pp. 66–71.

Salvioni, Daniela. "Interview with McCollum and Koons." *Flash Art* (Milan), international edition, no. 131 (Dec. 1986–Jan. 1987), pp. 66–68.

Politi, Giancarlo, with Paul Blanchard, Giancinto Di Pietrantonio, Elio Grazioli, Helena Kontova, Corrado Levi, and Gregorio Magnani. "Luxury and Desire: An Interview with Jeff Koons." *Flash Art* (Milan), international edition, no. 132 (Feb.–March 1987), pp. 71–76.

Staniszewski, Mary Anne. "Jeff Koons: Conceptual Art of the '60s and '70s Alienated the Viewer." *Flash Art* (Milan), international edition, no. 143 (Nov.–Dec. 1988), pp. 113–14.

Burke and Hare. "From Full Fathom Five." *Parkett* (Zurich), no. 19 (1989), pp. 44–47.

Collings, Matthew. "'You Are a White Man, Jeff. . . .'" *Modern Painters* (London) 2, no. 2 (summer 1989), pp. 60–63.

Sischy, Ingrid, and Karen Marta. "Artist Linked to Porn Star." *Interview* (New York) 20, no. 2 (Feb. 1990), p. 32.

Renton, Andrew. "Jeff Koons: I Have My Finger on the Eternal." *Flash Art* (Milan), international edition, no. 153 (summer 1990), pp. 110–15.

Storr, Robert. "Jeff Koons: Gym-Dandy." *Art Press* (Paris), no. 151 (Oct. 1990), pp. 14–23.

Hayt-Atkins, Elizabeth. "Jeff Koons, Jeffrey Deitch: Flying First Class out of the 80s toward the Year 2000." *Flash Art* (Milan), international edition, no. 162 (Jan.–Feb. 1992), pp. 158–59.

Sischy, Ingrid. "The Cat Is out of the Bag." *Interview* (New York) 27, no. 2 (Feb. 1997), pp. 90–95, 119.

Kontova, Helena, and Giancarlo Politi. "Jeff Koons: Ten Years Later." *Flash Art* (Milan), international edition, no. 195 (summer 1997), pp. 102–08.

Bowie, David. "Super-Banalism and the Innocent Salesman." *Modern Painters* (London) 11, no. 1 (spring 1998), pp. 27–34.

Koons, Jeff. Statement. *Flash Art* (Milan), international edition, no. 201 (summer 1998), pp. 88–89.

Rosenquist, James. "If You Get a Little Red on You, It Don't Wipe Off." *Parkett* (Zurich), no. 58 (2000), pp. 36–43.

Lauer, Matt. "Jeff Koons Discusses His Sculpture of 'Puppy,' Which Is Now at Rockefeller Plaza for the Summer." Transcript from *The Today Show*, NBC-TV, June 6, 2000, 7 a.m., lexis-nexis.com.

Solomon, Deborah. "Puppy Love: Questions for Jeff Koons." *The New York Times Magazine*, June 25, 2000, p. 15.

Books, Articles, and Essays

Ammann, Jean-Christophe. "Jeff Koons: A Case Study." *Parkett* (Zurich), no. 19 (1989), pp. 56–59.

Artner, Alan G. "Market Valued: What Jeff Koons Says about the Art World Today." *The Chicago Tribune*, July 31, 1988, section 13, pp. 16–17.

Attias, Laurie. "A Kinder, Gentler Koons." *ArtNews* (New York) 97, no. 3 (March 1998), pp. 158–61.

———. "Giant Koons Sculpture to Flower in Avignon." *Art and Auction* (New York) 22, no. 8 (May 2000), p. 38.

Avgikos, Jan. "All That Heaven Allows: Love, Honor, and Koonst." *Flash Art* (Milan), international edition, no. 171 (summer 1993), pp. 80–83.

Baring, Louise. "The Broader Picture: Would You Adam and Eve It?" *The Independent on Sunday* (London), March 31, 1991, pp. 32–33.

Beaumont, Peter. "Koons Is Accused over Kidnap of a Baby Snap." *The Observer* (London), June 12, 1994, p. 8.

Beech, Dave, and John Beagles. "All You Need Is Love." *Art Monthly* (London), no. 233 (Feb. 2000), pp. 1–4.

Bellet, Harry. "L'Homme aux chimères d'acier." *Le Monde* (Paris), May 24, 2000, pp. 4–5.

Bourriaud, Nicolas. "Jeff Koons: Ingénieur du désir." *Beaux Arts* (Paris), no. 160 (Sept. 1997), pp. 42–49.

Buskirk, Martha. "Appropriation under the Gun." *Art in America* (New York) 80, no. 6 (June 1992), pp. 37–40.

———. "Commodification as Censor: Copyrights and Fair Use." *October* (New York), no. 60 (spring 1992), pp. 82–109.

Cameron, Dan. "Art and Its Double." *Flash Art* (Milan), international edition, no. 134 (May 1987), pp. 58–71.

———. "Pretty as a Product." *Arts* (New York) 60, no. 9 (May 1986), pp. 22–25.

Cembalest, Robin. "The Case of the Purloined Puppy Photo." *ArtNews* (New York) 91, no. 5 (May 1992), pp. 35–36.

Cone, Timothy. "Fair Use? Rogers v. Koons." *Arts* (New York) 66, no. 4 (Dec. 1991), pp. 25–26.

Craven, David. "Science Fiction and the Future of Art." *Arts* (New York) 58, no. 9 (May 1984), pp. 125–29.

Dannat, Adrian. "The 'Mine' Field." *The Independent* (London), March 23, 1992, Arts section, p. 20.

Diederichsen, Diedrich. "I'll Buy That." *Parkett* (Zurich), no. 19 (1989), pp. 74–77.

Edenbaum, Seth. "Parody and Privacy." *Arts* (New York) 62, no. 2 (Oct. 1987), pp. 44–45.

Genosko, Gary. "Cute Art." *Border Crossings* (Winnipeg, Canada) 18, no. 4 (fall 1999), pp. 12, 14.

Gibson, Jeff. "Santa's Little Helper: Sydney Hosts Jeff Koons and More." *Flash Art* (Milan), international edition, no. 187 (March–April 1996), p. 38.

Goodeve, Thyrza Nichols. "Euphoric Enthusiasm: Jeff Koons's Celebration." *Parkett* (Zurich), nos. 50–51 (1997), pp. 88–93.

Gopnik, Adam. "Lust for Life." *The New Yorker*, May 18, 1992, pp. 76–78.

Hall, James. "Neo-Geo's Bachelor Artists." *Art International* (Paris), no. 9 (winter 1989), pp. 30–35.

———. "They Call It Puppy Love." *The Guardian* (London), Oct. 29, 1992, pp. 4–5.

Halley, Peter. "The Crisis in Geometry." *Arts* (New York), 58, no. 10 (June 1984), pp. 111–15.

Hays, Constance L. "A Picture, a Sculpture, and a Lawsuit." *The New York Times*, Sept. 19, 1991, p. B2.

Heartney, Eleanor. "Simulationism: The Hot New Cool Art." *ArtNews* (New York) 86, no. 1 (Jan. 1987), pp. 130–37.

Issak, Jo Anna. "The Friends of Jeff Koons Fan Club." *Artforum* (New York) 30, no. 6 (Feb. 1992), p. 86.

The Jeff Koons Handbook. London: Anthony d'Offay Gallery, 1992. With texts by Robert Rosenblum and the artist.

— Amoroux, Éric. "Robert Rosenblum: The Jeff Koons Handbook." *Cahiers du Musée d'Art Moderne* (Paris), nos. 45–46 (autumn–winter 1993), p. 201.

— Barker, Godfrey. "Jeff Koons Speaks Up." *The Daily Telegraph* (London), Feb. 8, 1993, p. 15.

— Graham-Dixon, Andrew. "In a Pig's Eye." *The Independent* (London), Nov. 10, 1992, p. 18.

— "The Jeff Koons Handbook—Book Reviews." *Publishers Weekly* (New York), 240, no. 5 (Feb. 1, 1993), p. 86.

Jodidio, Philip. "Ileana la Reine, Koons le Roi." *Connaissance des Arts* (Paris), no. 451 (Sept. 1989), pp. 108–09.

Joselit, David. "Investigating the Ordinary." *Art in America* (New York) 76, no. 5 (May 1988), pp. 148–55.

Joseph, Joe. "Penetrating Art Dekko." *The Times Saturday Review* (London), Oct. 17, 1992, pp. 23–25.

Kenner, Robert. "The New Shock." *Art and Antiques* (New York) 7, no. 7 (Oct. 1990), p. 33.

Kertess, Klaus. "Bad." *Parkett* (Zurich), no. 19 (1989), pp. 30–35.

Koether, Jutta. "Puppy Logic." *Artforum* (New York) 31, no. 1 (Sept. 1992), p. 90.

Lacayo, Richard. "Artist Jeff Koons Makes, and Earns, Giant Figures." *People Weekly* (New York), May 8, 1989, pp. 127–32.

Laurent, Rachel. "Objets manipulés, avez-vous donc une me?" *Art Press* (Paris), no. 148 (June 1990), pp. 44–47.

Lee, David. "American Art: The Good, the Bad, and Julian Schnabel." *Arts Review* (London) 45 (Nov. 1993), pp. 32–39.

Littlejohn, David. "Who Is Jeff Koons and Why Are People Saying Such Terrible Things about Him?" *ArtNews* (New York) 92, no. 4 (April 1993), pp. 90–94.

Loers, Veit. "Puppy, the Sacred Heart of Jesus." *Parkett* (Zurich), nos. 50–51 (1997), pp. 85–87.

Morgan, Stuart, Jutta Koether, David Salle, and Sherrie Levine. "Big Fun: Four Reactions to the New Jeff Koons." *Artscribe International* (London), no. 74 (March–April 1989), pp. 46–49.

Muniz, Vik. "Eternal Regress." *Parkett* (Zurich), nos. 50–51 (1997), pp. 61–67.

Muthesius, Angelika, ed. *Jeff Koons*. Cologne: Benedikt Taschen, 1992. With interview by Anthony Haden-Guest, text by Jean-Christophe Ammann, and statements by the artist (in German, French, and English).

O'Brien, Glenn. "Koons Ad Nauseam." *Parkett* (Zurich), no. 19 (1989), pp. 62–64.

Pinchbeck, Daniel. "Kitsch and Tell." *Connoisseur* (New York), no. 221 (Nov. 1991), pp. 30–36, 124–26.

Ratcliff, Carter, and Rhonda Lieberman. "Not for Repro." *Artforum* (New York) 30, no. 6 (Feb. 1992), pp. 82–86.

Reginato, James. "Crafty Koons," *W* (New York) 29, no. 4 (April 2000), pp. 396–402.

Rimanelli, David. "It's My Party: Jeff Koons, A Studio Visit." *Artforum* (New York) 35, no. 10 (summer 1997), pp. 112–17.

Rimbali, Paul. "Arts Diary: Adam and Eve in Disneyland." *The Guardian* (London), Dec. 19, 1991, p. 22.

Rosenblum, Robert. "Jeff Koons: Christ and the Lamb." *Artforum* (New York) 32, no. 1 (Sept. 1993), pp. 148–49.

Rubinstein, Meyer Raphael, and Daniel Wiener. "Sites and Sights: Considerations on Walter De Maria, Jeff Koons, and Tom Butter." *Arts* (New York) 61, no. 7 (March 1987), pp. 20–21.

Saltz, Jerry. "The Dark Side of the Rabbit: Notes on a Sculpture by Jeff Koons." *Arts* (New York) 62, no. 6 (Feb. 1988), pp. 26–27.

Sawyer, Miranda. "She Was a Porn Star, He Was an Artist, Their Greatest Work Was Their Child, But Just Who Owns the Sculpture?" *The Observer* (London), Sept. 3, 1995, Life section, pp. 12–17.

Schjeldahl, Peter. "The Documenta of the Dog." *Art in America* (New York) 80, no. 9 (Sept. 1992), pp. 89–97, 77.

———. "A Visit to the Salon of Autumn 1986." *Art in America* (New York) 74, no. 12 (Dec. 1986), pp. 15–25.

Schwartzman, Allan. "The Yippie-Yuppie Artist." *Manhattan, Inc.* (New York) 4, no. 12 (Dec. 1987), pp. 137–43.

Seward, Keith. "Frankenstein in Paradise." *Parkett* (Zurich), nos. 50–51 (1997), pp. 68–81.

Smith, Roberta. "How Much Is That Doggy in the Courtyard?" *The New York Times*, July 5, 1992, p. 27.

——— "Rituals of Consumption." *Art in America* (New York) 76, no. 5 (May 1988), pp. 164–71.

Stamets, Bill. "The Culture Critics." *The New Art Examiner* (New York) 21, no. 4 (Dec. 1993), pp. 17, 19.

Sullivan, Ronald. "Appeals Court Rules Artist Pirated Picture of Puppies." *The New York Times*, April 3, 1992, p. B3.

Tarantino, Michael. "Gone Soft?" *Artforum* (New York) 29, no. 1 (Sept. 1990), p. 137.

Taylor, Paul. "The Art of P.R. and Vice Versa." *The New York Times*, Oct. 27, 1991, Arts and Leisure section, pp. 1, 35.

Tazzi, Pier Luigi. "The Critics' Way: Jeff Koons: Kiepenkerl." *Artforum* (New York) 26, no. 1 (Sept. 1987), p. 120.

Tillim, Sidney. "Ideology and Difference: Reflections on Olitski and Koons." *Arts* (New York) 63, no. 7 (March 1989), pp. 48–51.

Westenholm, Margot. "Scharlatan und Superstar: Jeff Koons." *Pan* (Offenburg, Germany), no. 2 (1989), p. 11.

Yardley, Jonathan. "The Compromise of Art." *The Washington Post*, Sept. 23, 1991, p. C2.

Credits

..................................

Pages 1, 6, 9, 12-13, 44-45, 47, 48, 53, 54, 72-73: Jeff Koons studio photographs, David Heald

Pages 15, 16, 19, 24: Lawrence Beck, Courtesy Sonnabend Gallery, New York

Pages 20, 28, 31, 33–35, 37–39, 41, 42: Douglas M. Parker

Page 21, 50 (Jeff Koons studio photograph): Ellen Labenski

Page 23: Nathan Kernan

Page 25: Courtesy Galerie Jérôme de Noirmont, Paris

Page 26: Mike Bruce, Gate Studios, London, Courtesy the Royal Academy of Arts, London

Page 30: Zindman/Fremont

Pages 57–71: Plates, David Heald and Ellen Labenski

Special thanks to Grotte di Frasassi, Genga, Italy [Plate 7].